Trippin Fest Kid's Edition

MARVELOUS MODERN ART

Trippin-Fest Creations
Kid's Edition

Trippin Fest Kid's Edition
By: Jewels Gold

Dedicated to:

*My Two Beautiful Children,
who created the artwork in this book and
inspired my heart to be full of color and joy!*

Trippin Fest Kid's Edition

A note from the author, Jewels Gold:

Art has become an integral part of the day around my place and it couldn't have come at a better time! With the little ones demanding more and more of my attention and also needing that stimulation to encourage their little minds to grow...I found that art would play an important part of that development for them as well as an enhancement to my own personal development. We started out with the creations in this book using a fun and fascinating little iphone app called "Trippin-Fest". Here is what we created as we began our artistic journey together.......

Trippin Fest Kid's Edition

Trippin Fest Kid's Edition

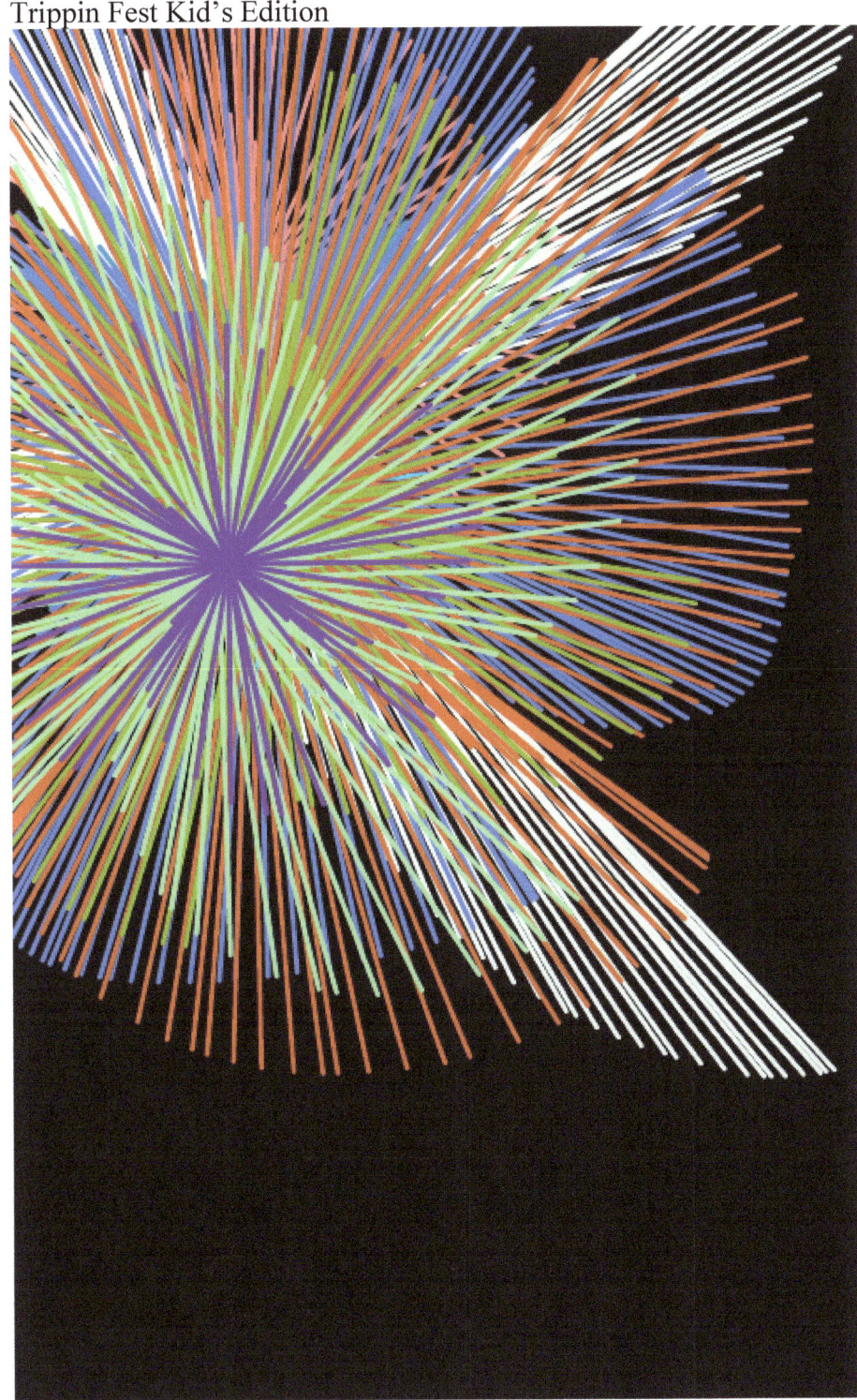

Trippin Fest Kid's Edition

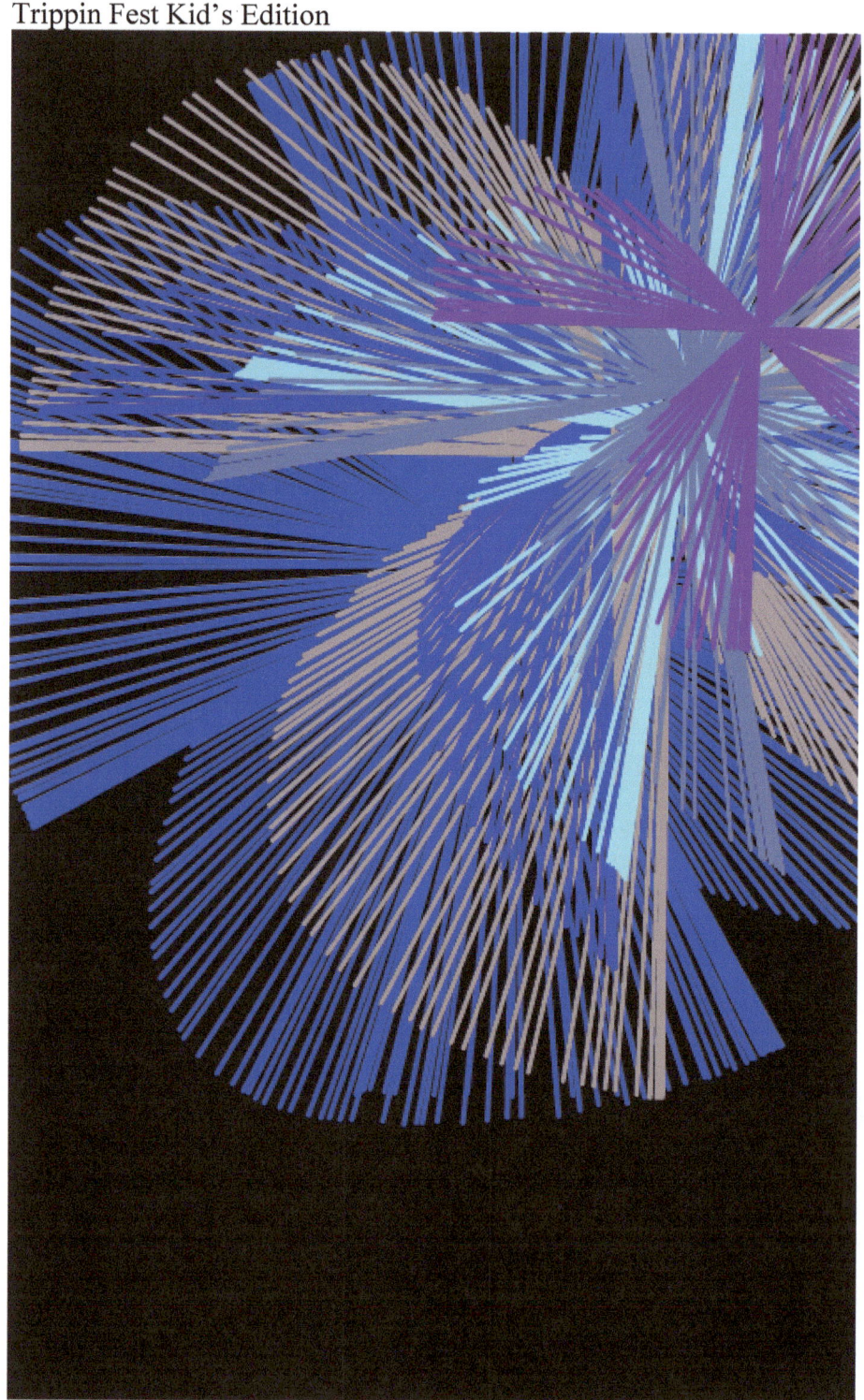

Trippin Fest Kid's Edition

Trippin Fest Kid's Edition

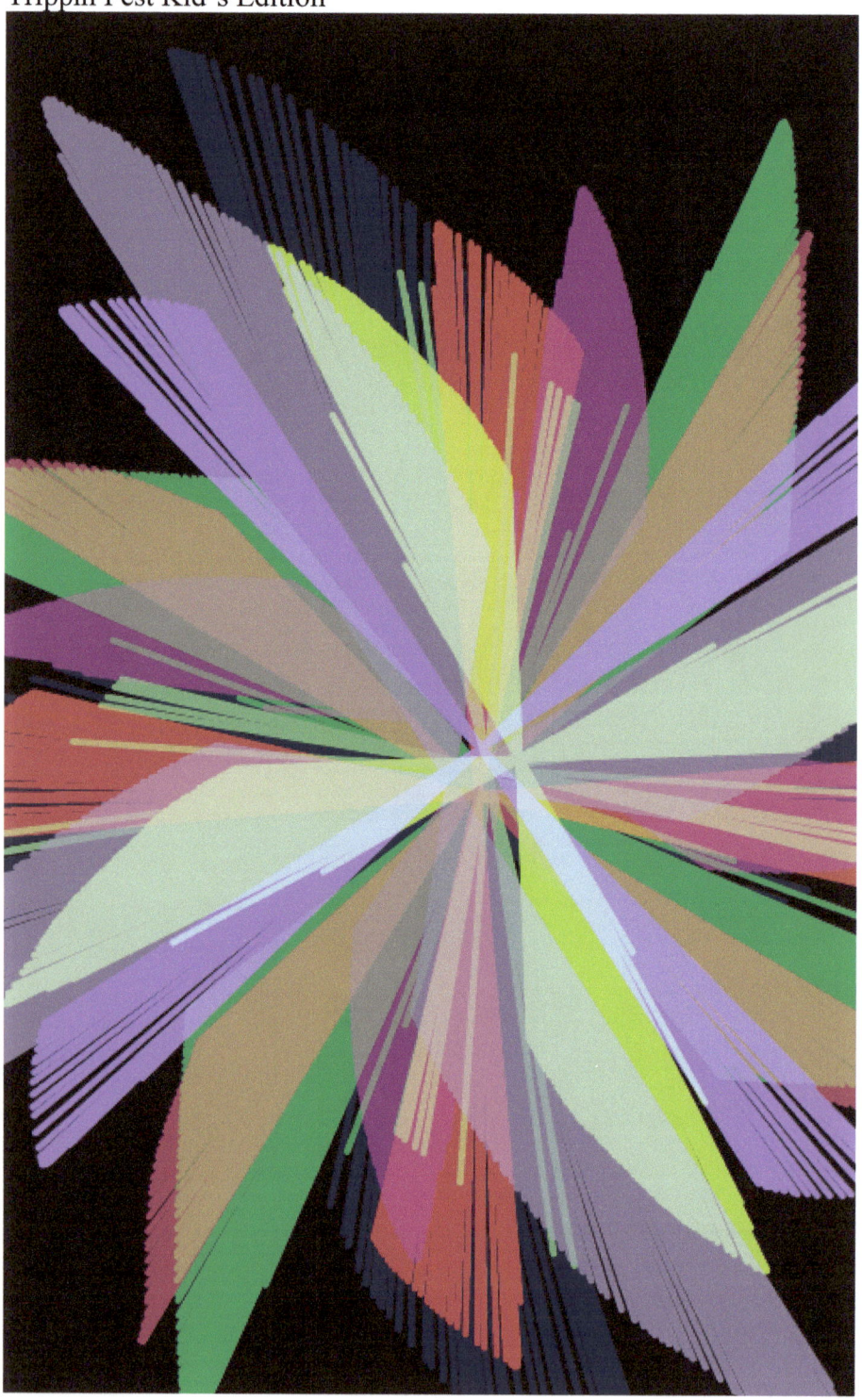

Trippin Fest Kid's Edition

Trippin Fest Kid's Edition

Trippin Fest Kid's Edition

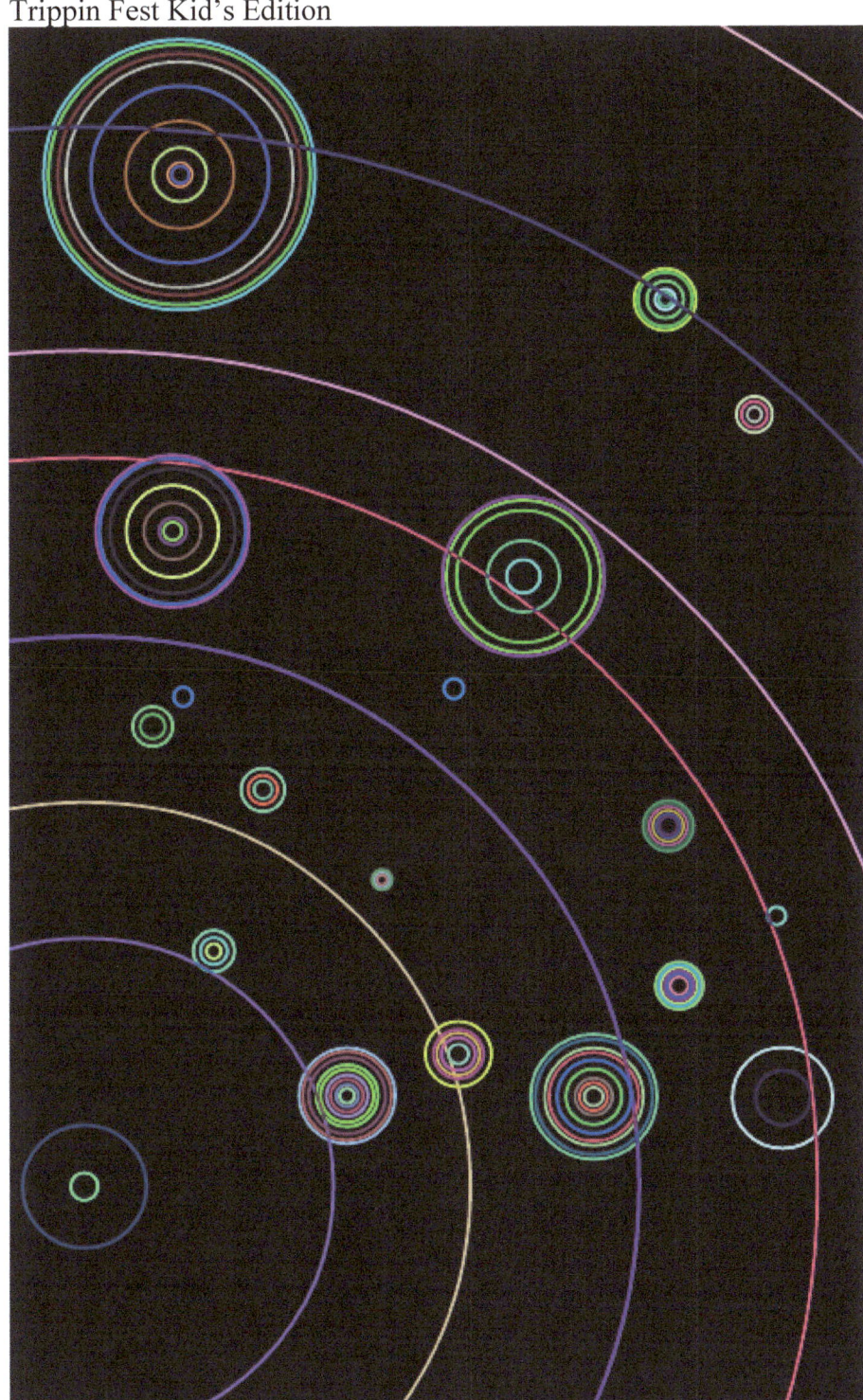

Trippin Fest Kid's Edition

Trippin Fest Kid's Edition

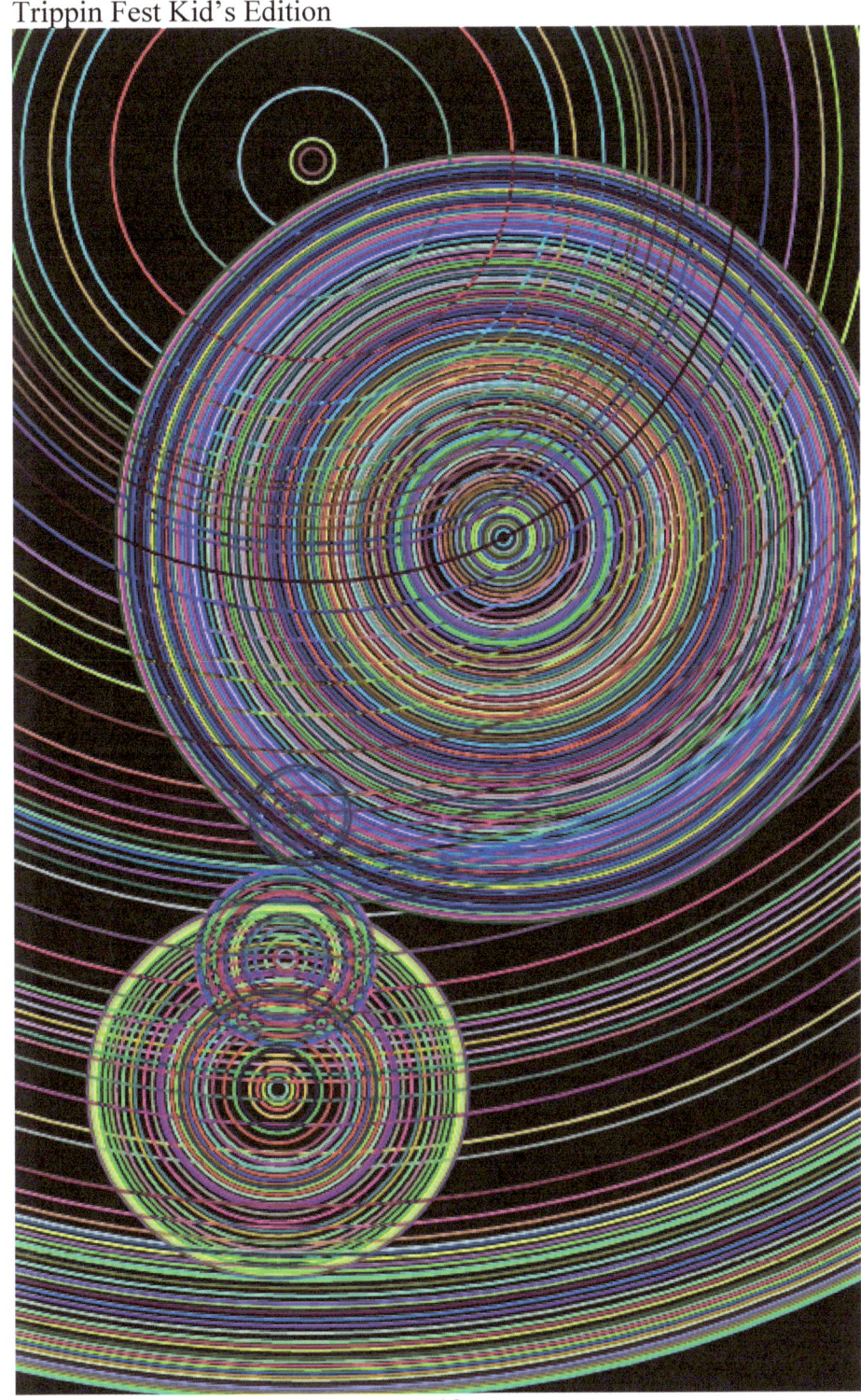

Trippin Fest Kid's Edition

Trippin Fest Kid's Edition

Trippin Fest Kid's Edition

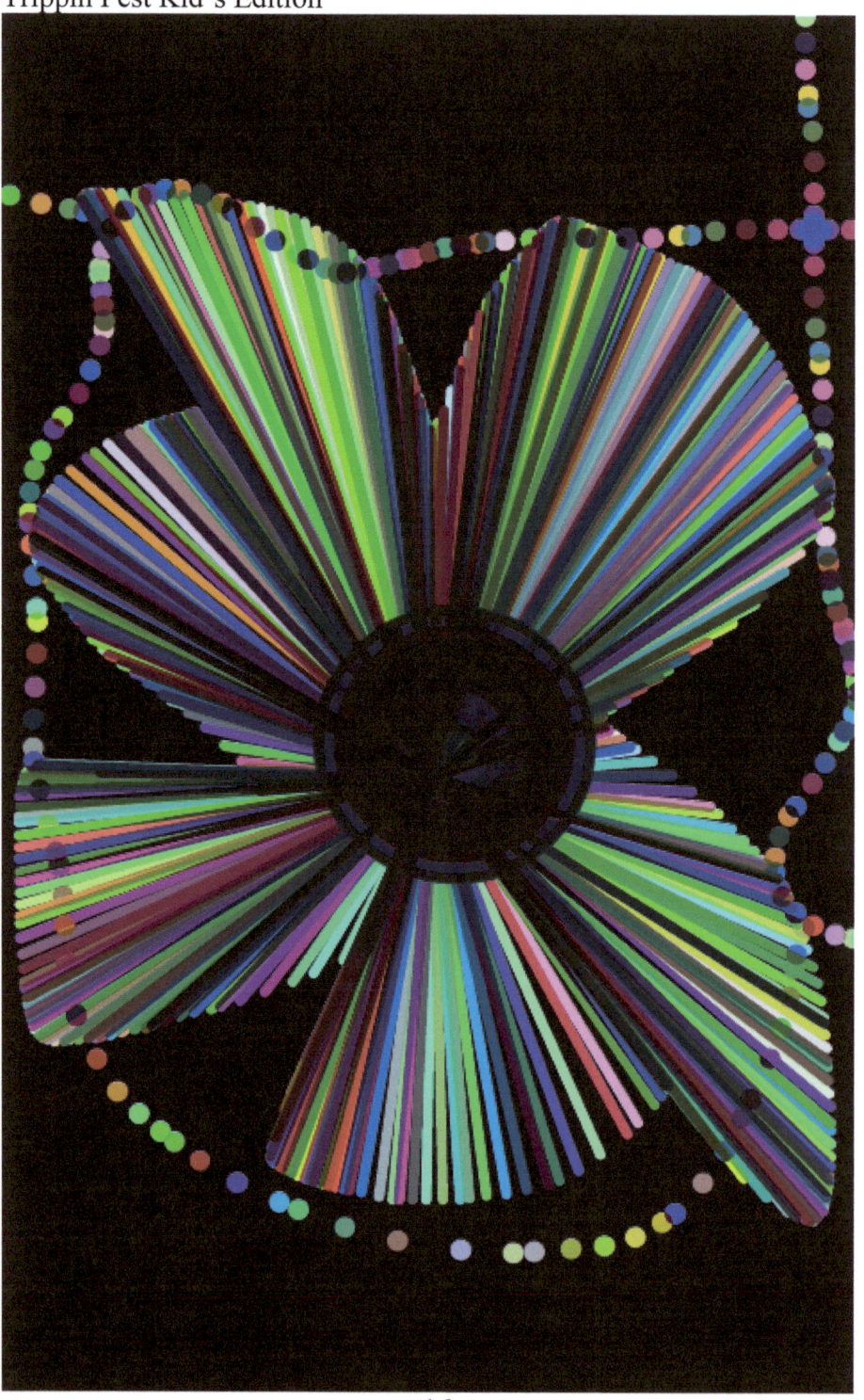

Trippin Fest Kid's Edition

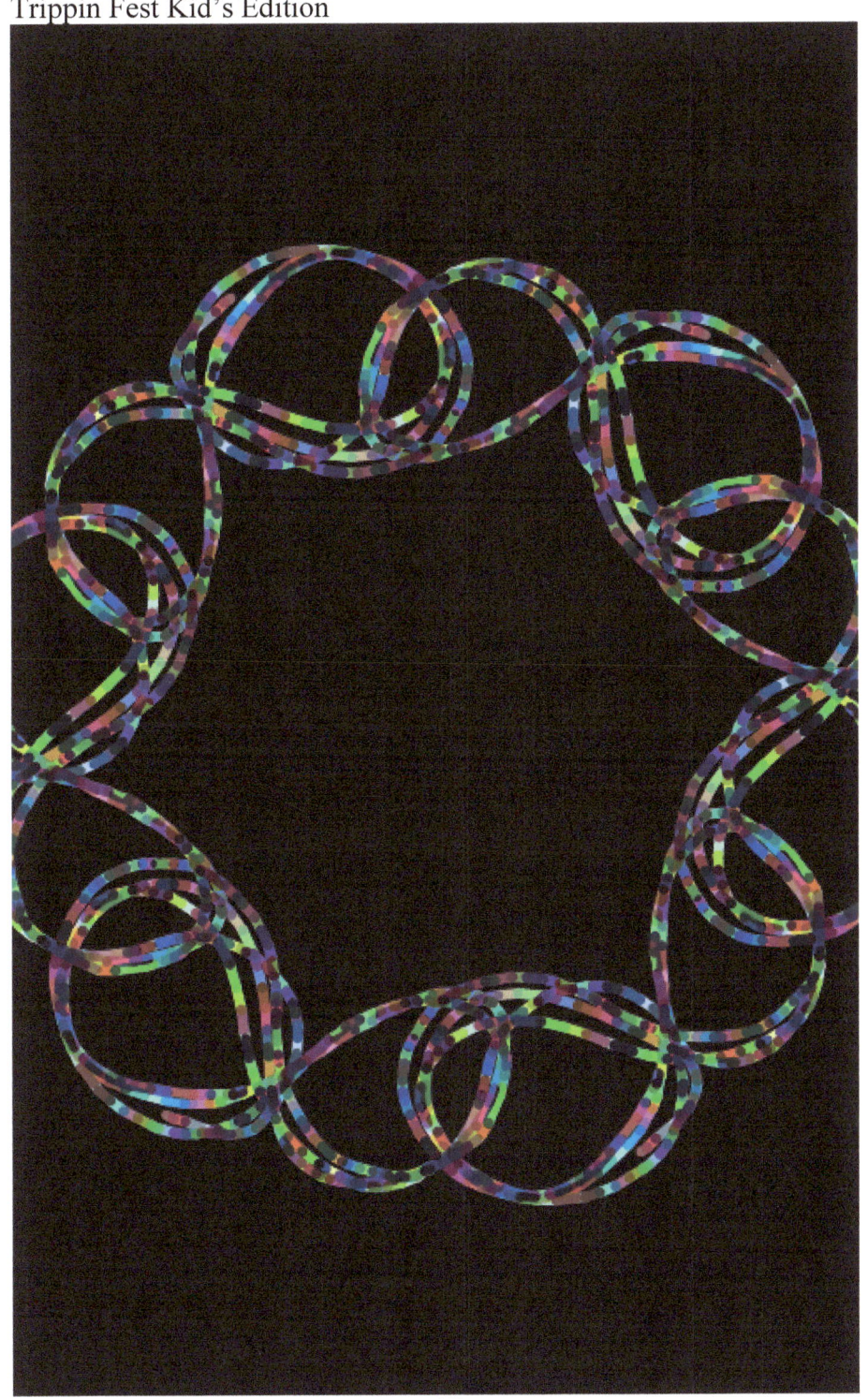

Trippin Fest Kid's Edition

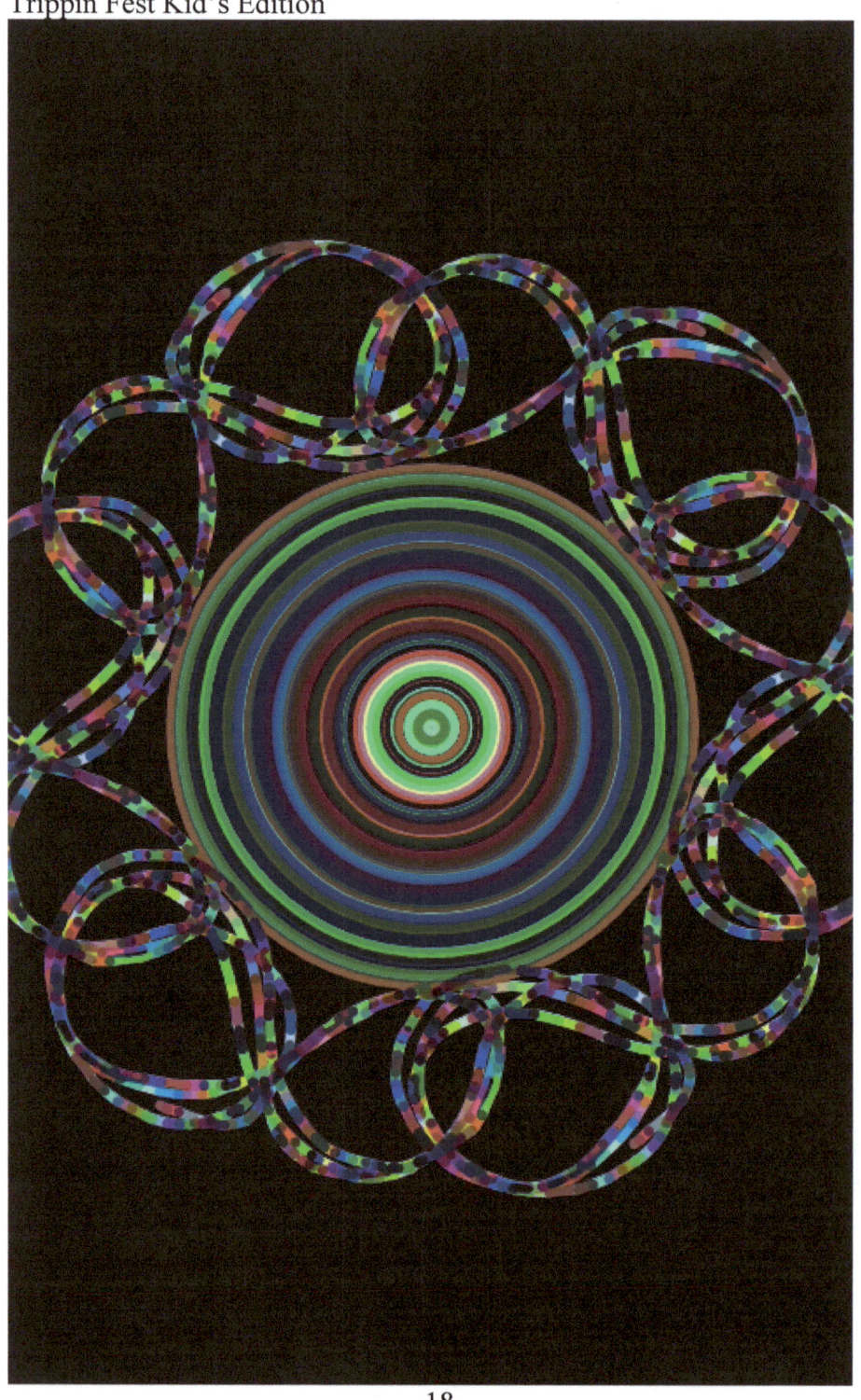

Trippin Fest Kid's Edition

Trippin Fest Kid's Edition

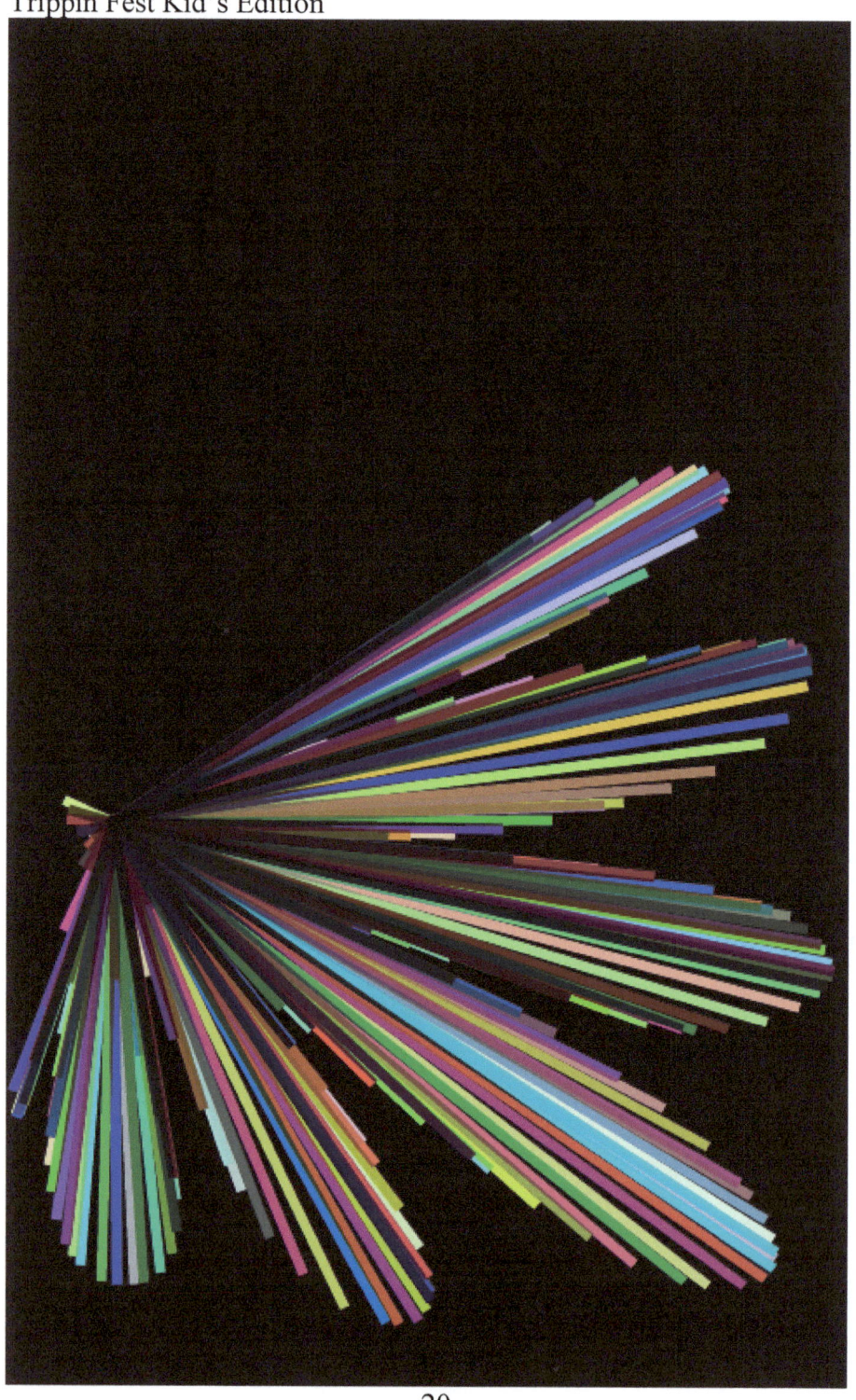

Trippin Fest Kid's Edition

Trippin Fest Kid's Edition

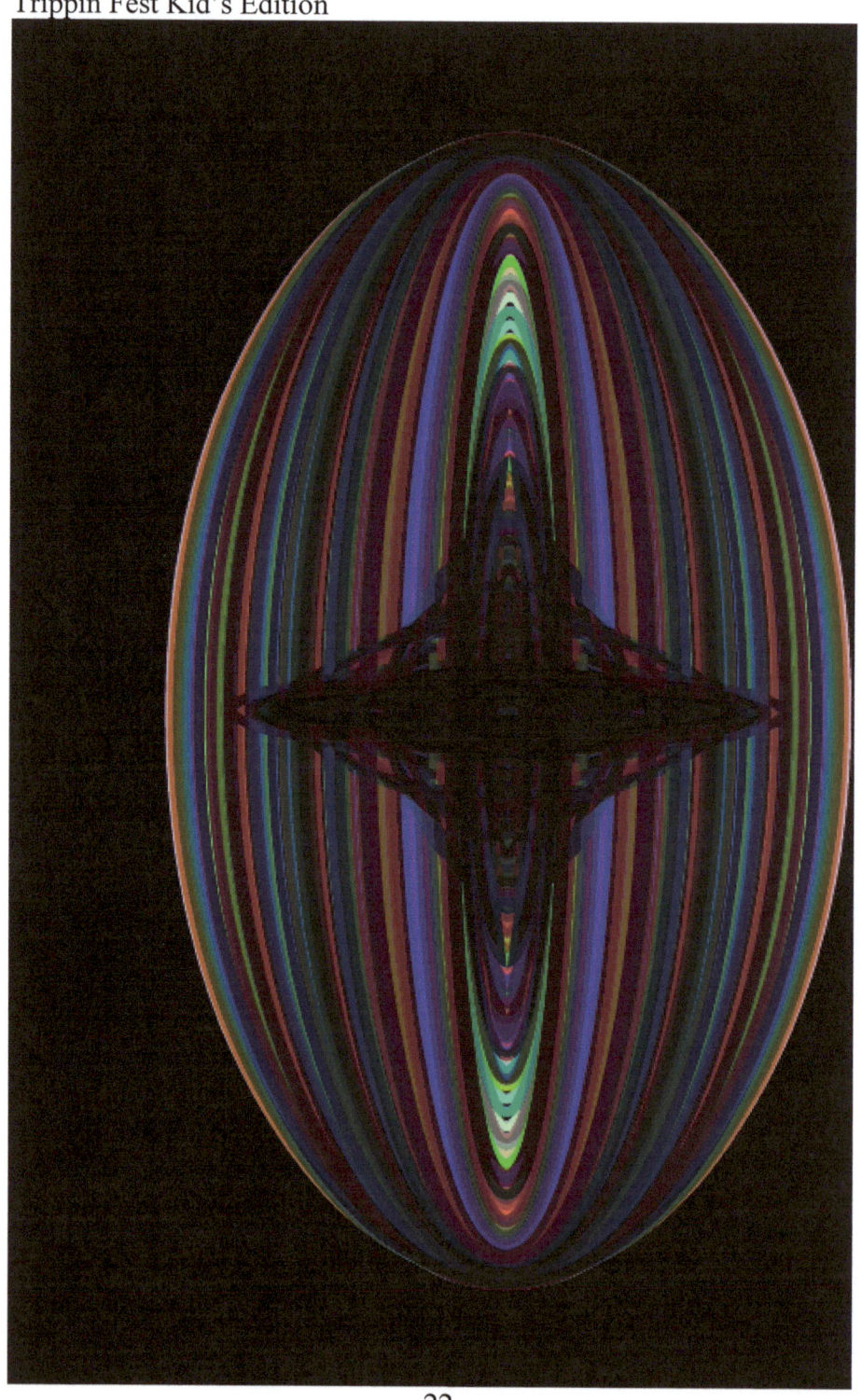

Trippin Fest Kid's Edition

Trippin Fest Kid's Edition

Trippin Fest Kid's Edition

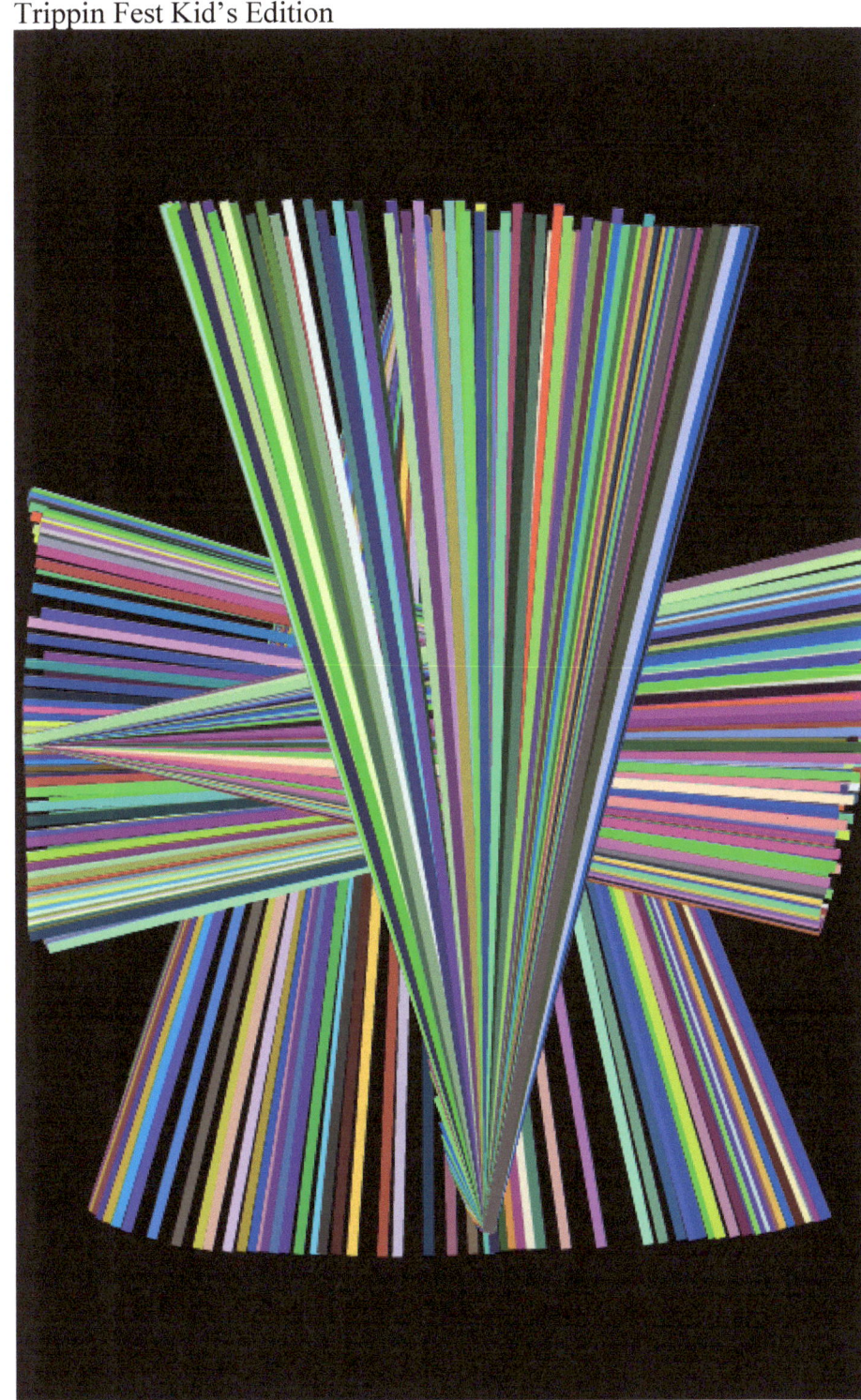

Trippin Fest Kid's Edition

Trippin Fest Kid's Edition

Trippin Fest Kid's Edition

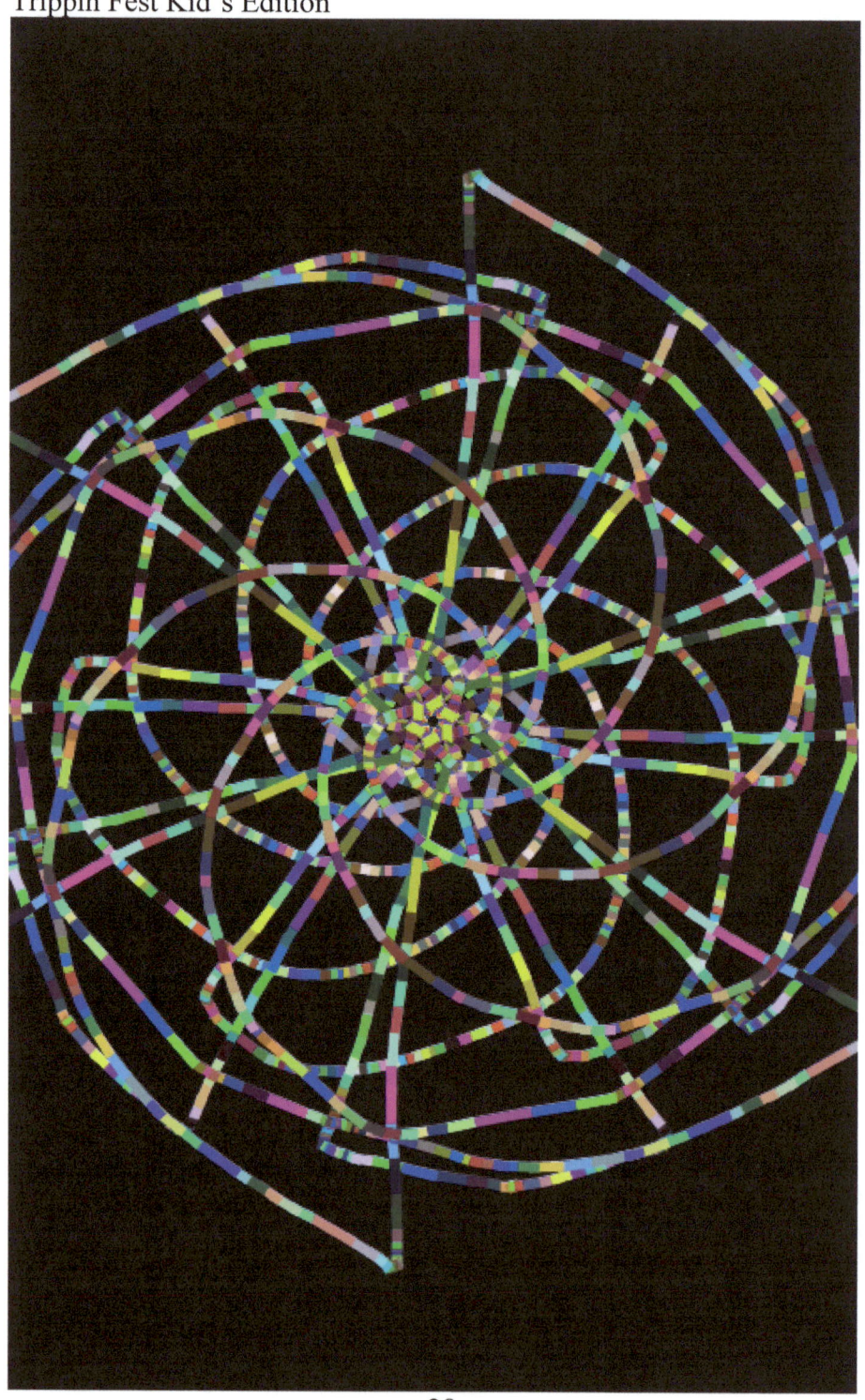

Trippin Fest Kid's Edition

Trippin Fest Kid's Edition

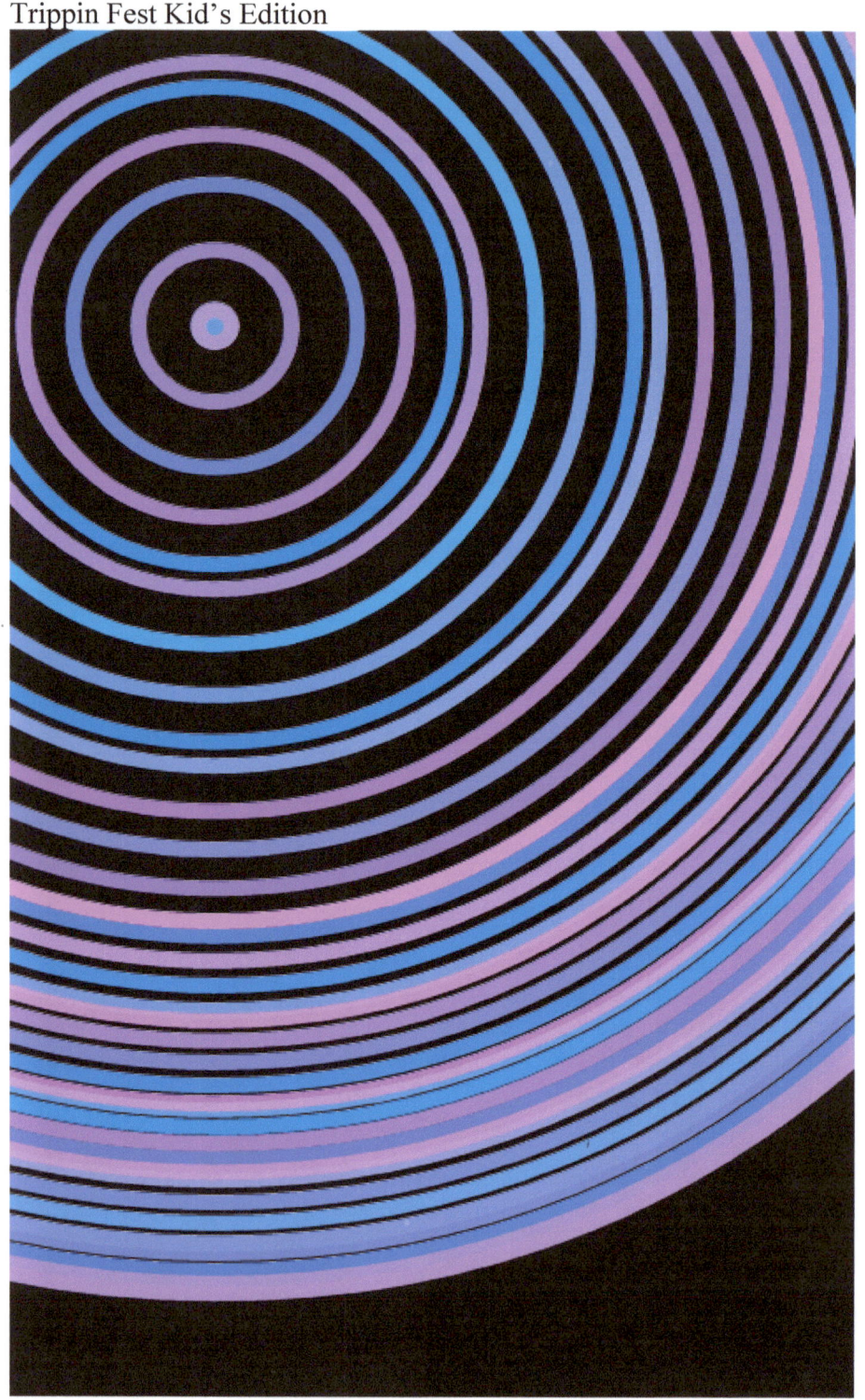

Trippin Fest Kid's Edition

Trippin Fest Kid's Edition

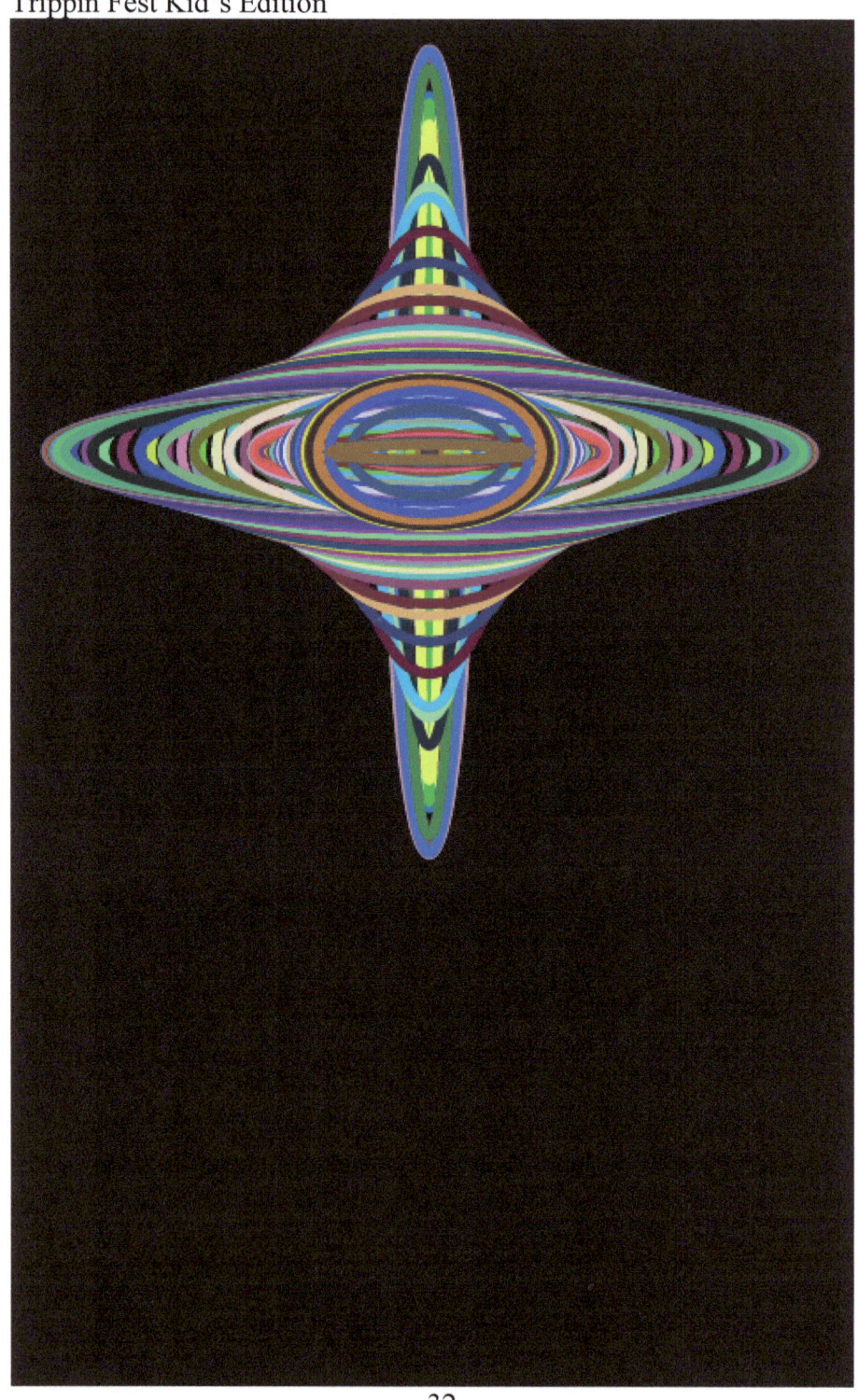

Trippin Fest Kid's Edition

Trippin Fest Kid's Edition

Trippin Fest Kid's Edition

Trippin Fest Kid's Edition

Trippin Fest Kid's Edition

Trippin Fest Kid's Edition

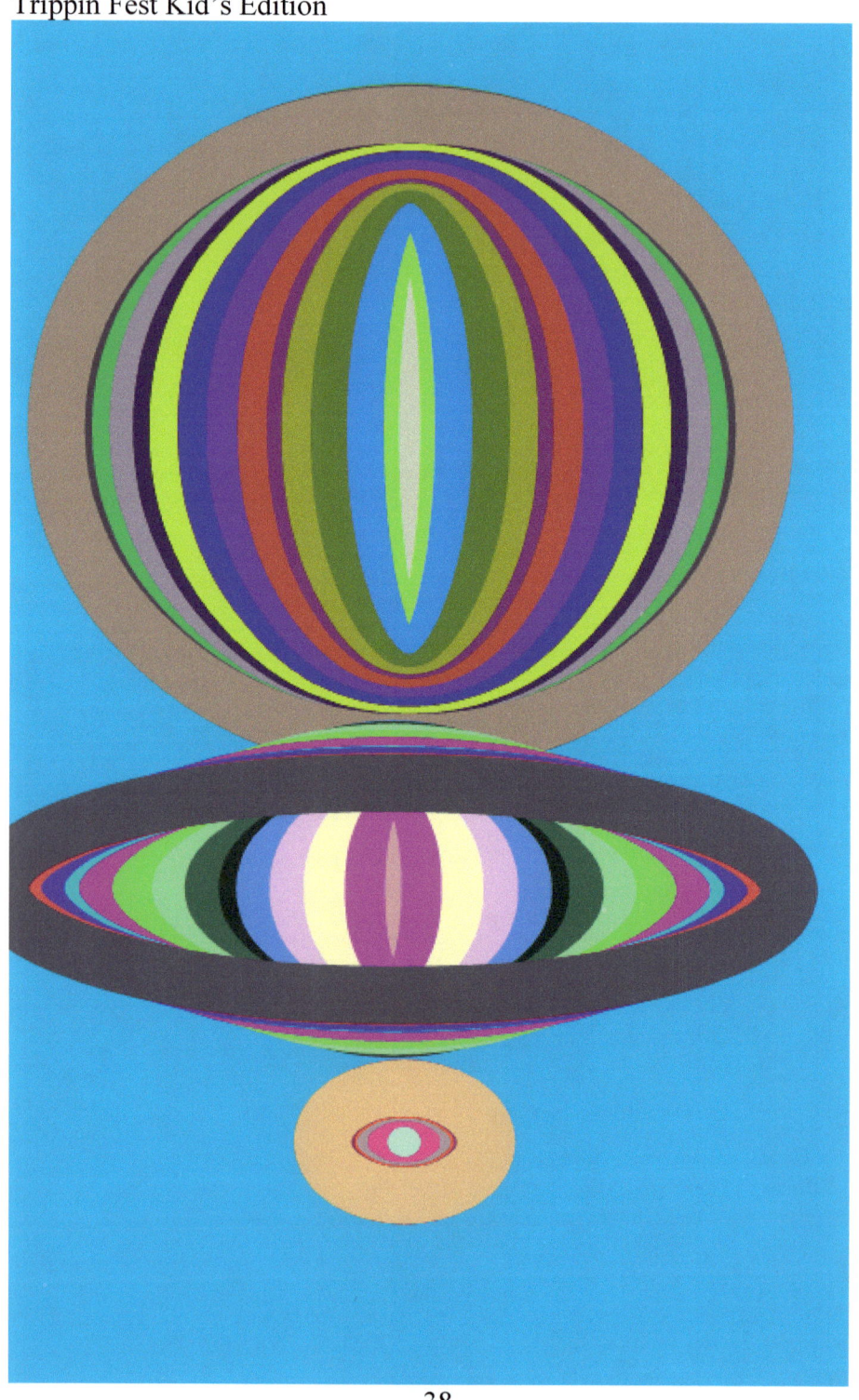

Trippin Fest Kid's Edition

Trippin Fest Kid's Edition

Trippin Fest Kid's Edition

Trippin Fest Kid's Edition

Trippin Fest Kid's Edition

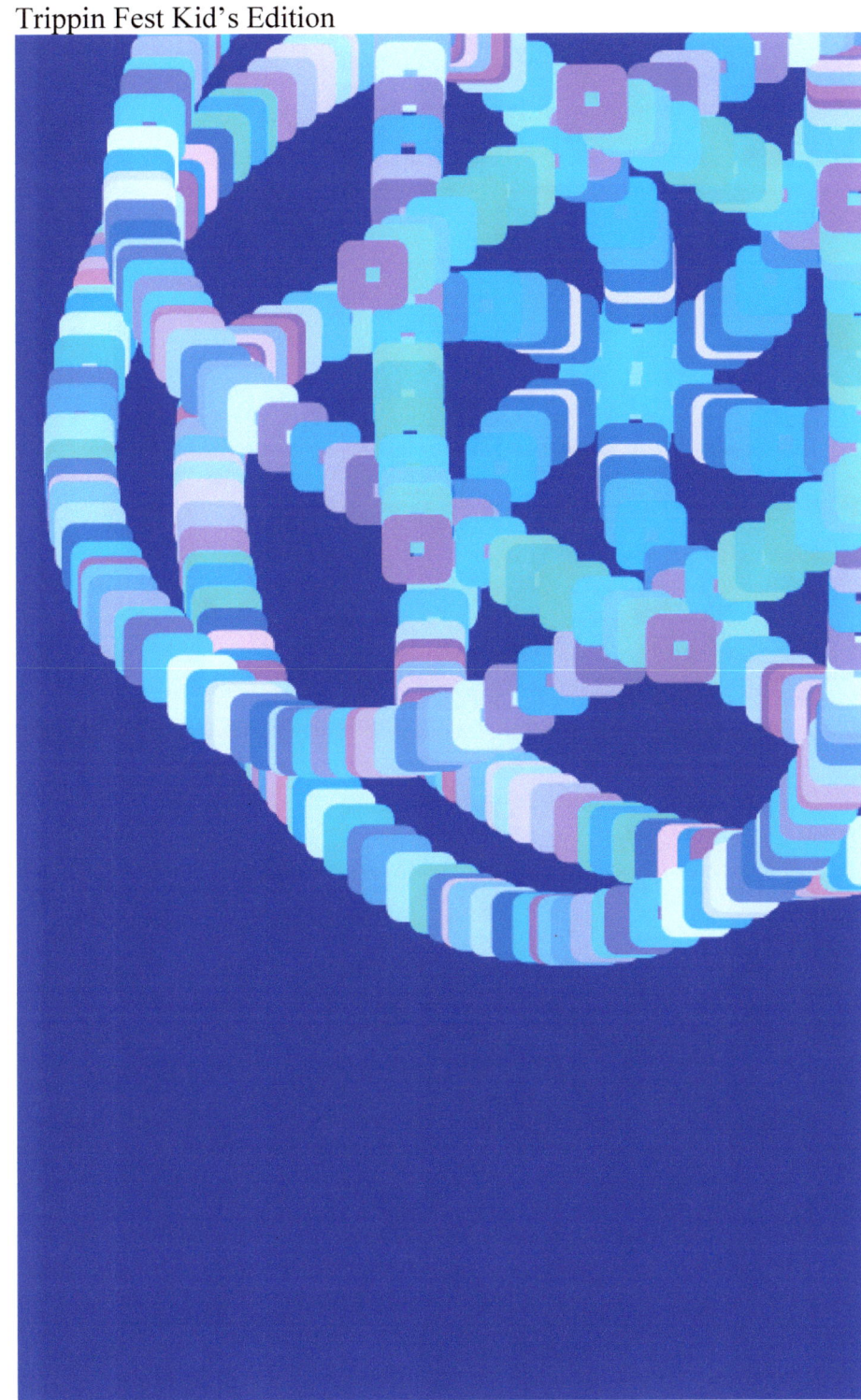

Trippin Fest Kid's Edition

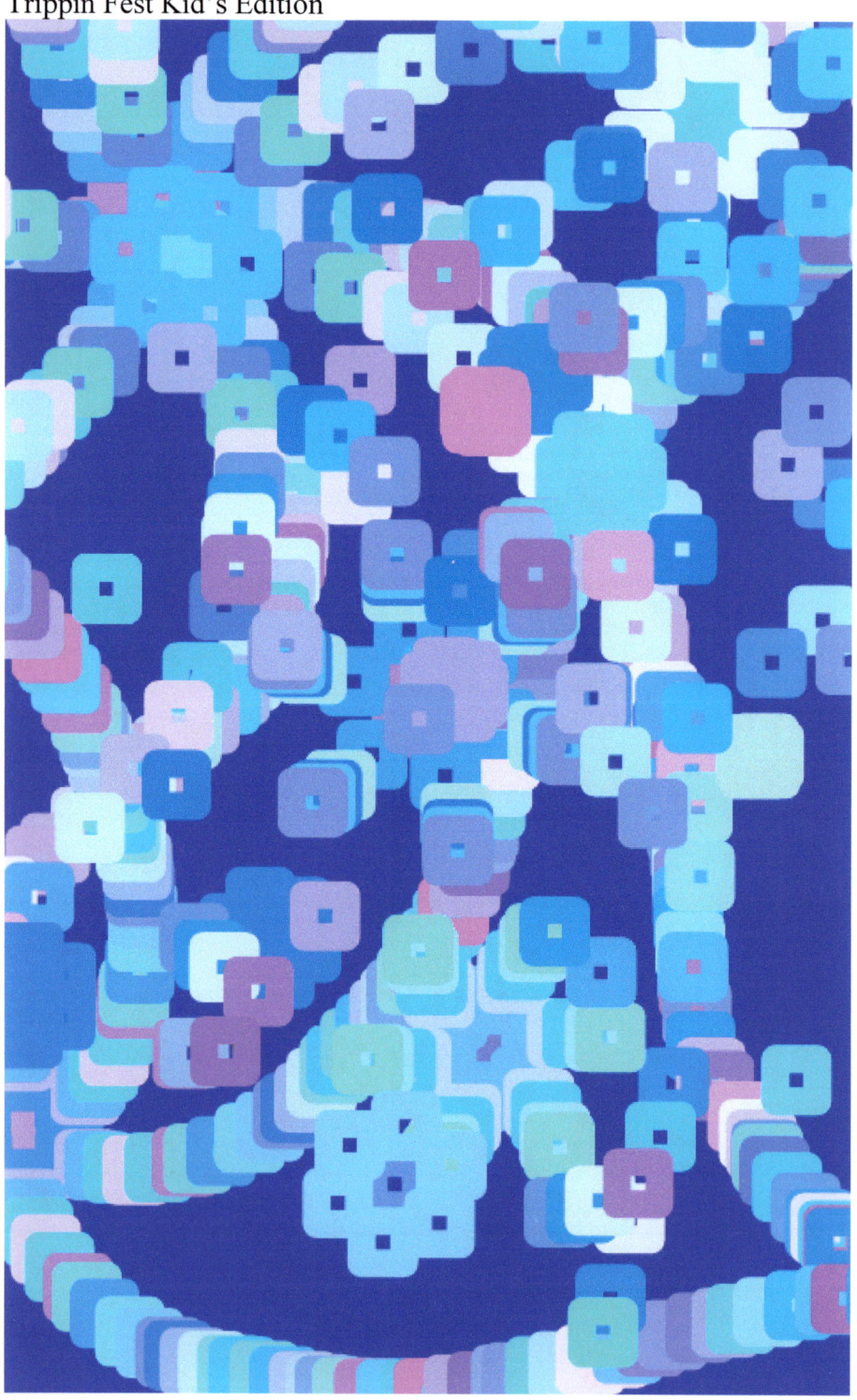

Trippin Fest Kid's Edition

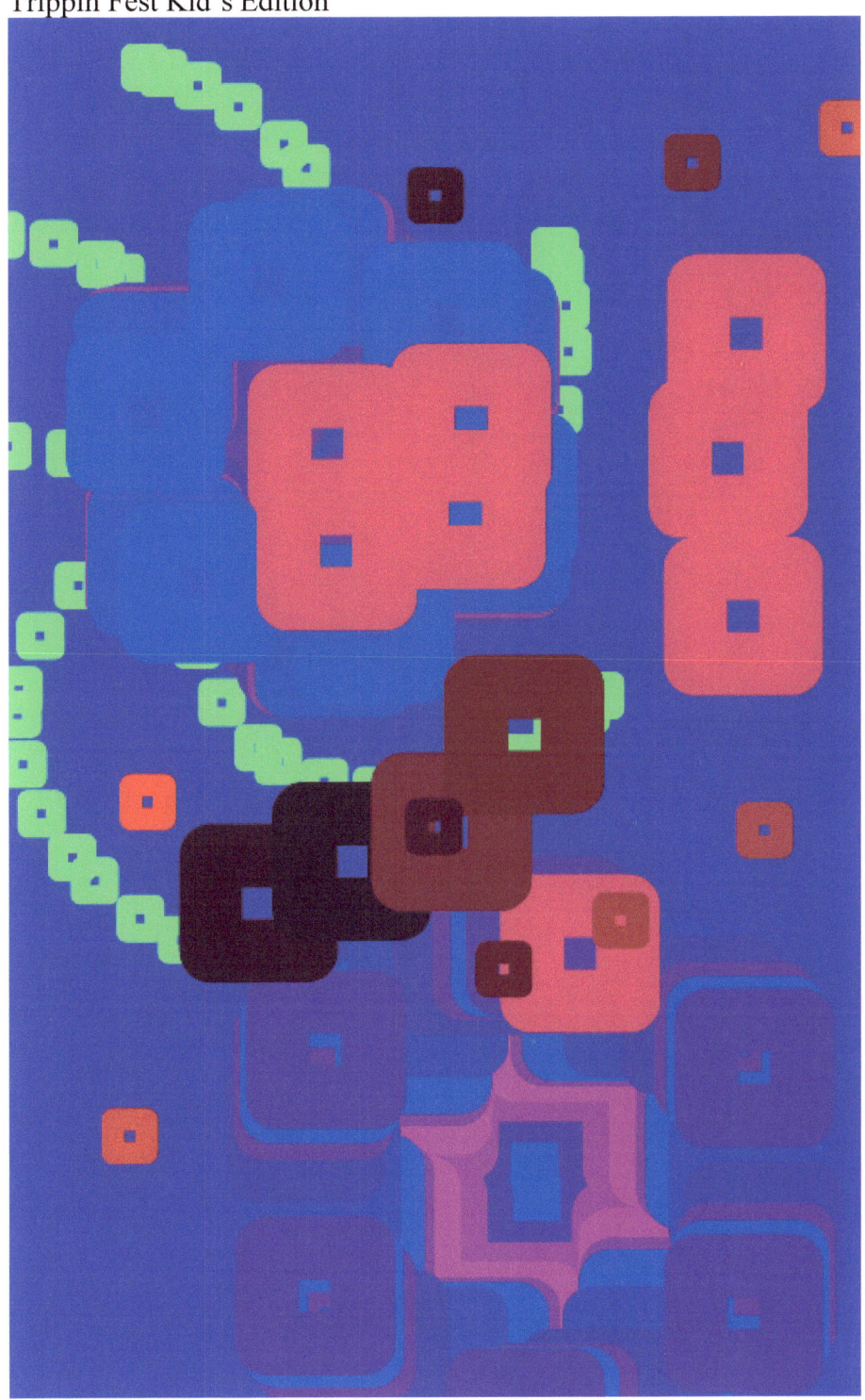

Trippin Fest Kid's Edition

Trippin Fest Kid's Edition

Trippin Fest Kid's Edition

Trippin Fest Kid's Edition

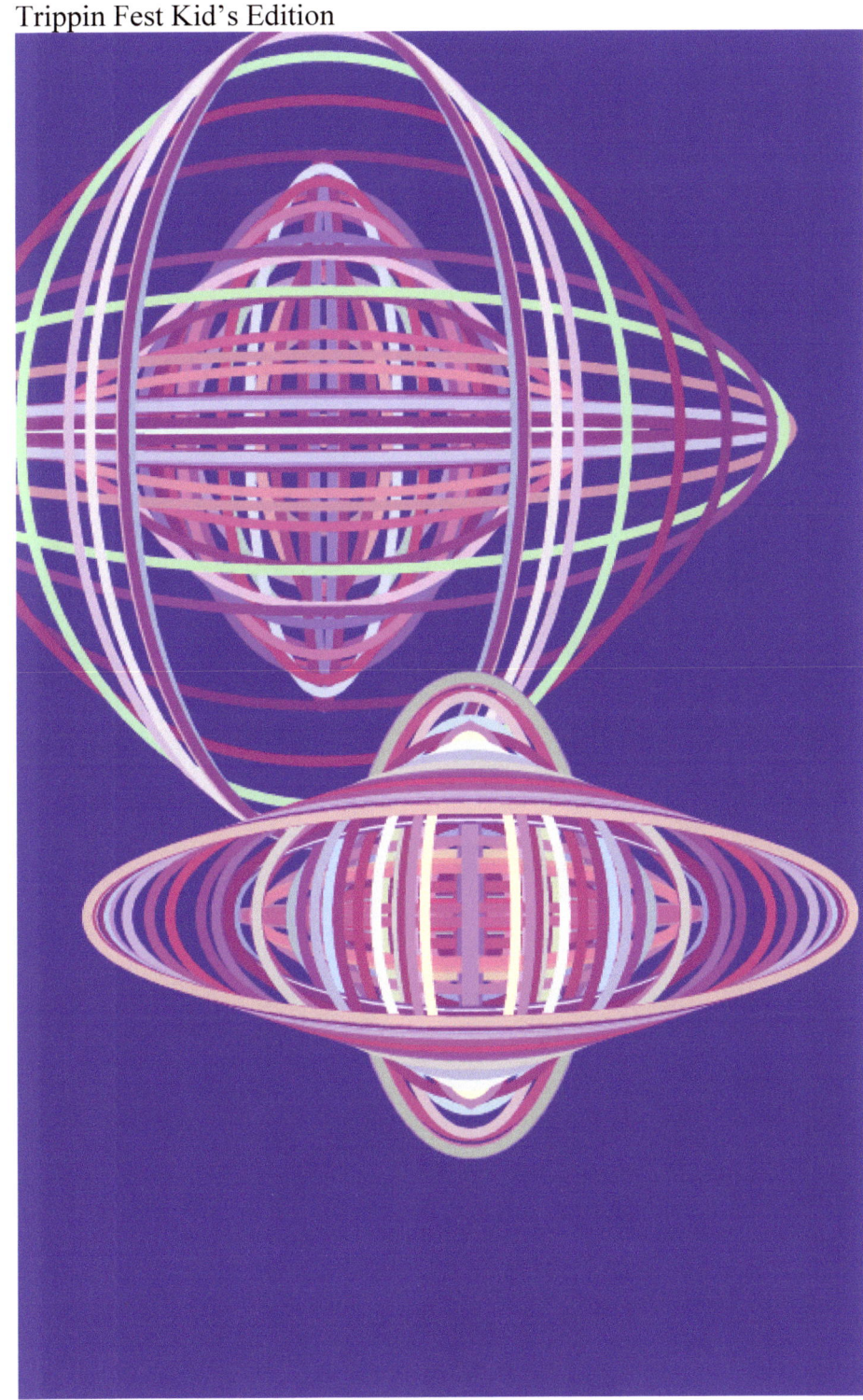

Trippin Fest Kid's Edition

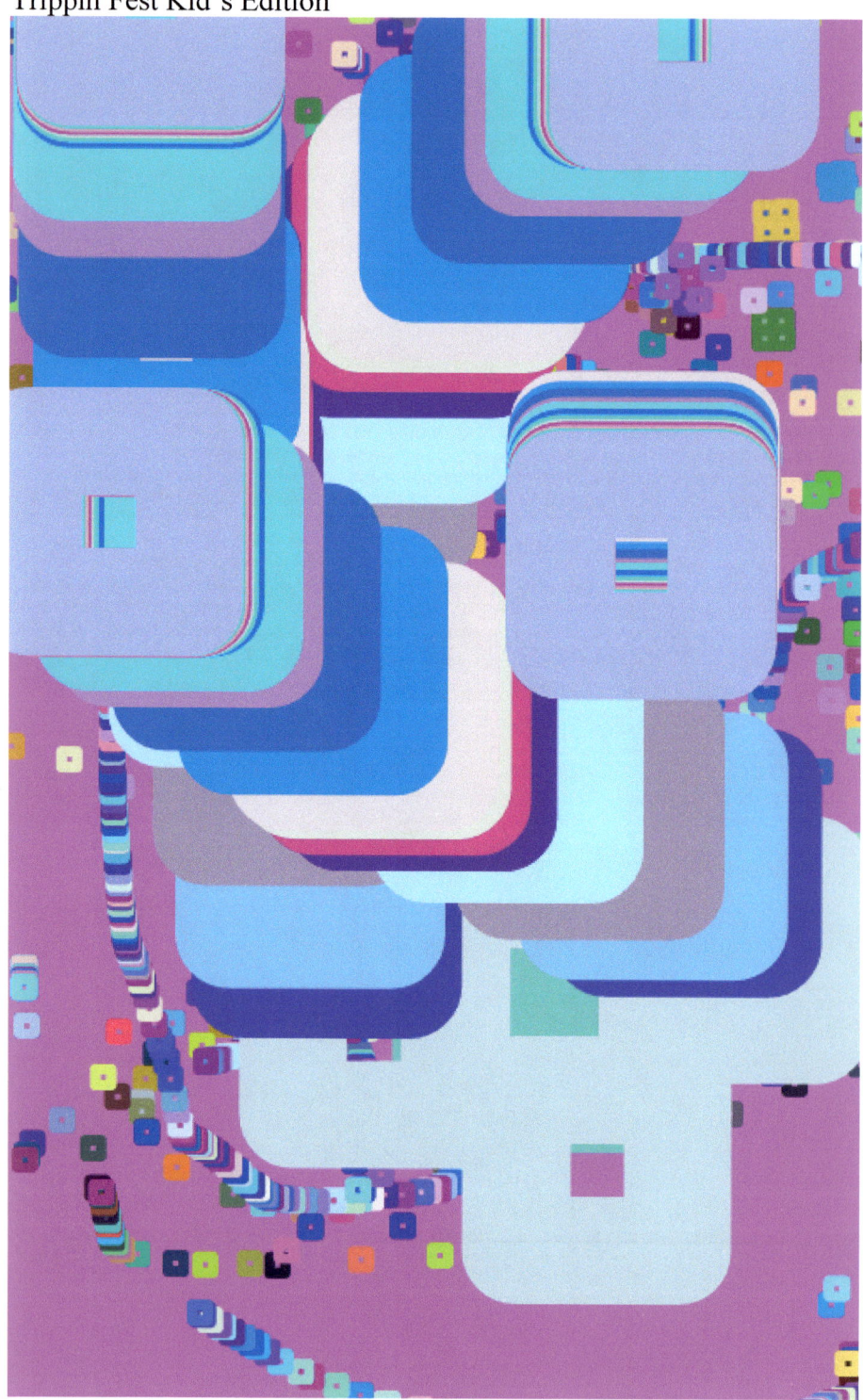

Trippin Fest Kid's Edition

Trippin Fest Kid's Edition

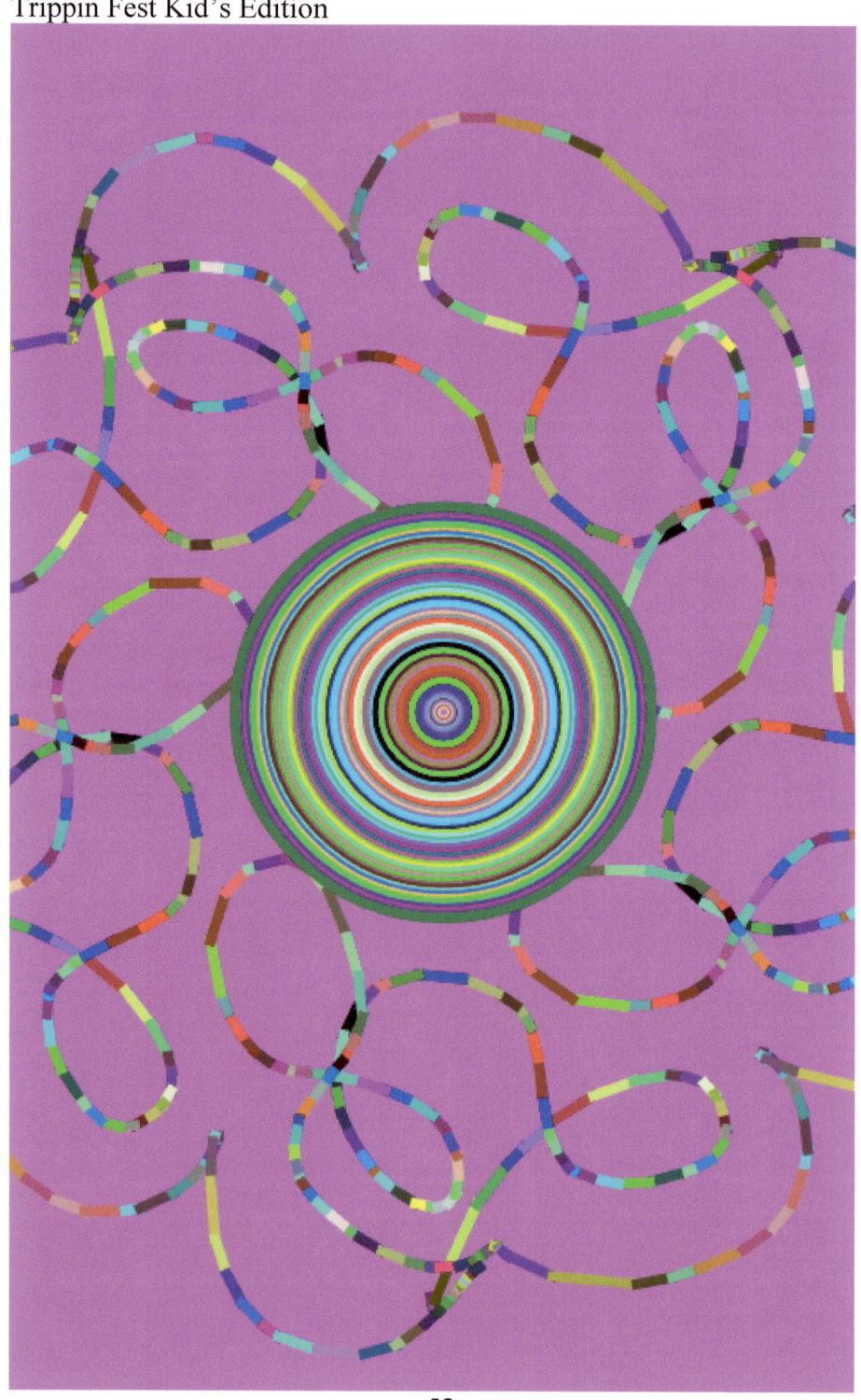

Trippin Fest Kid's Edition

Trippin Fest Kid's Edition

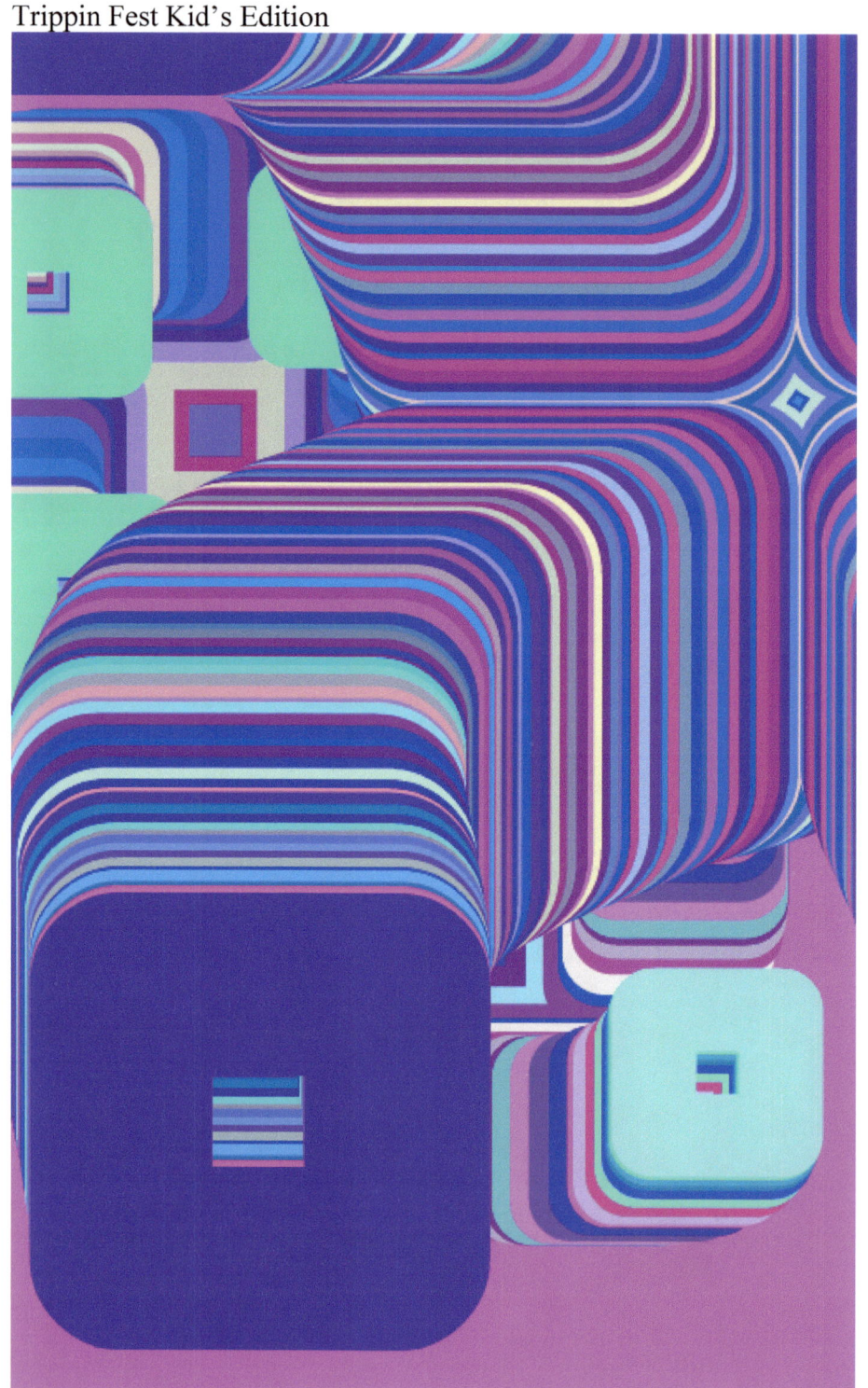

Trippin Fest Kid's Edition

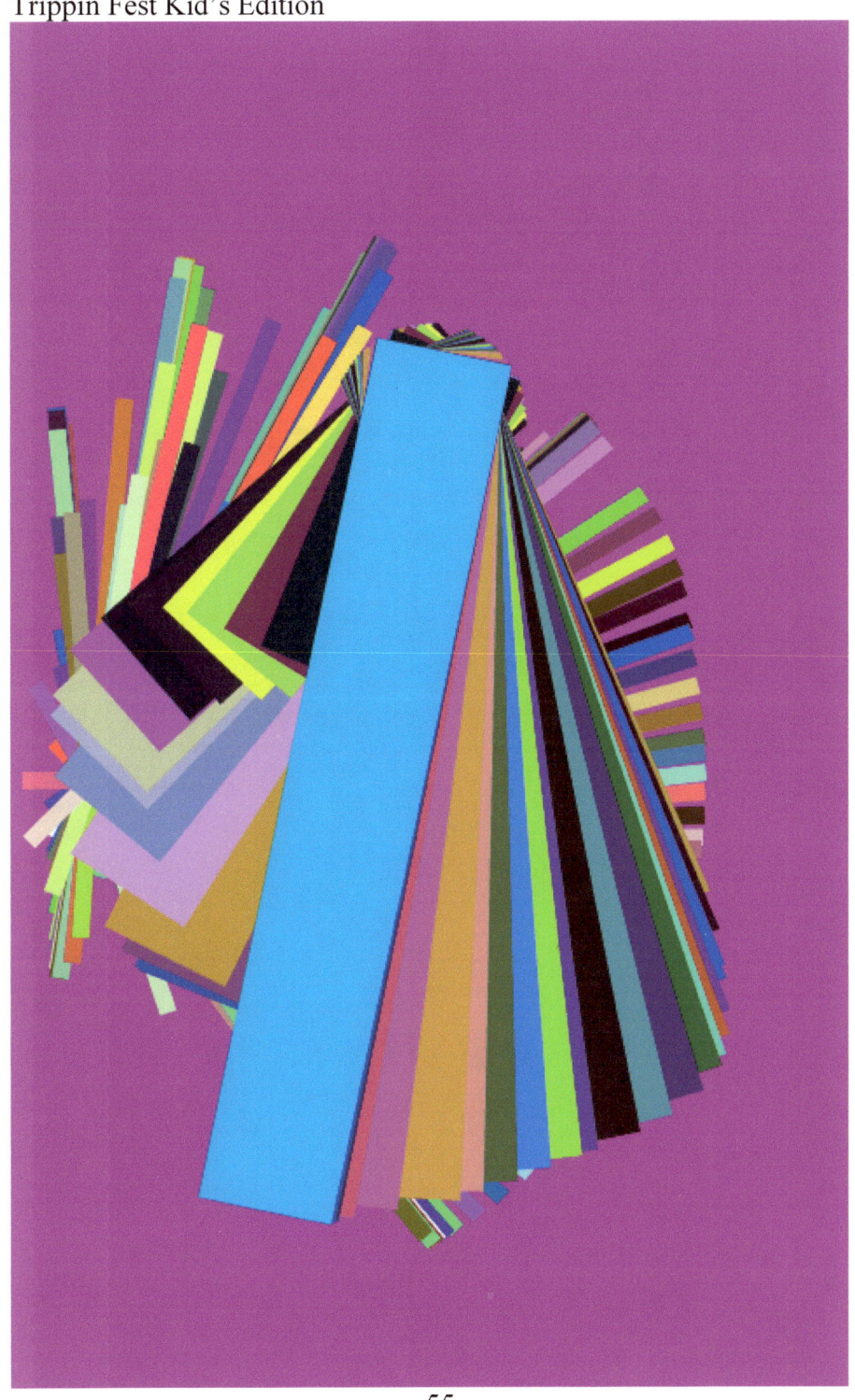

Trippin Fest Kid's Edition

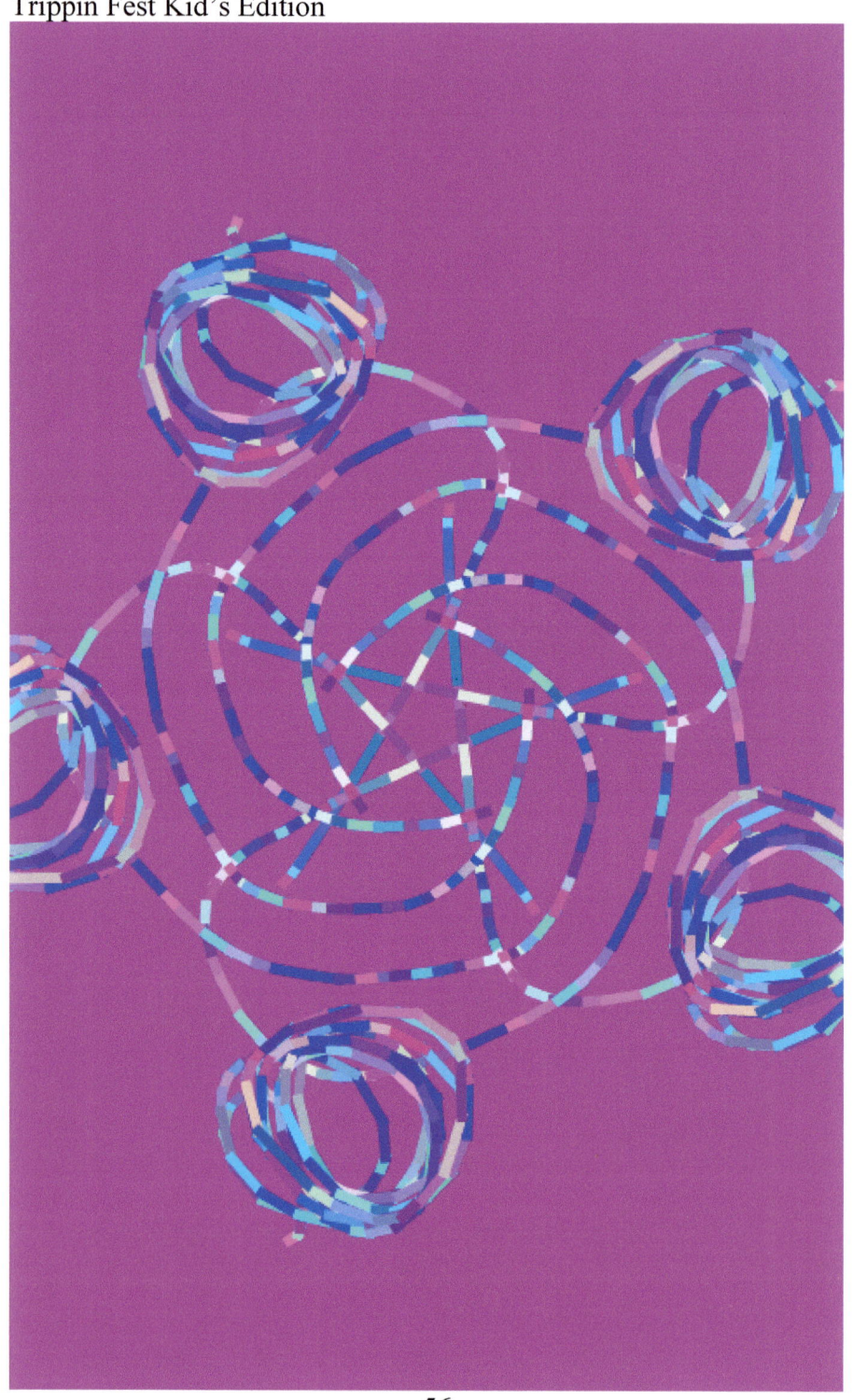

Trippin Fest Kid's Edition

Trippin Fest Kid's Edition

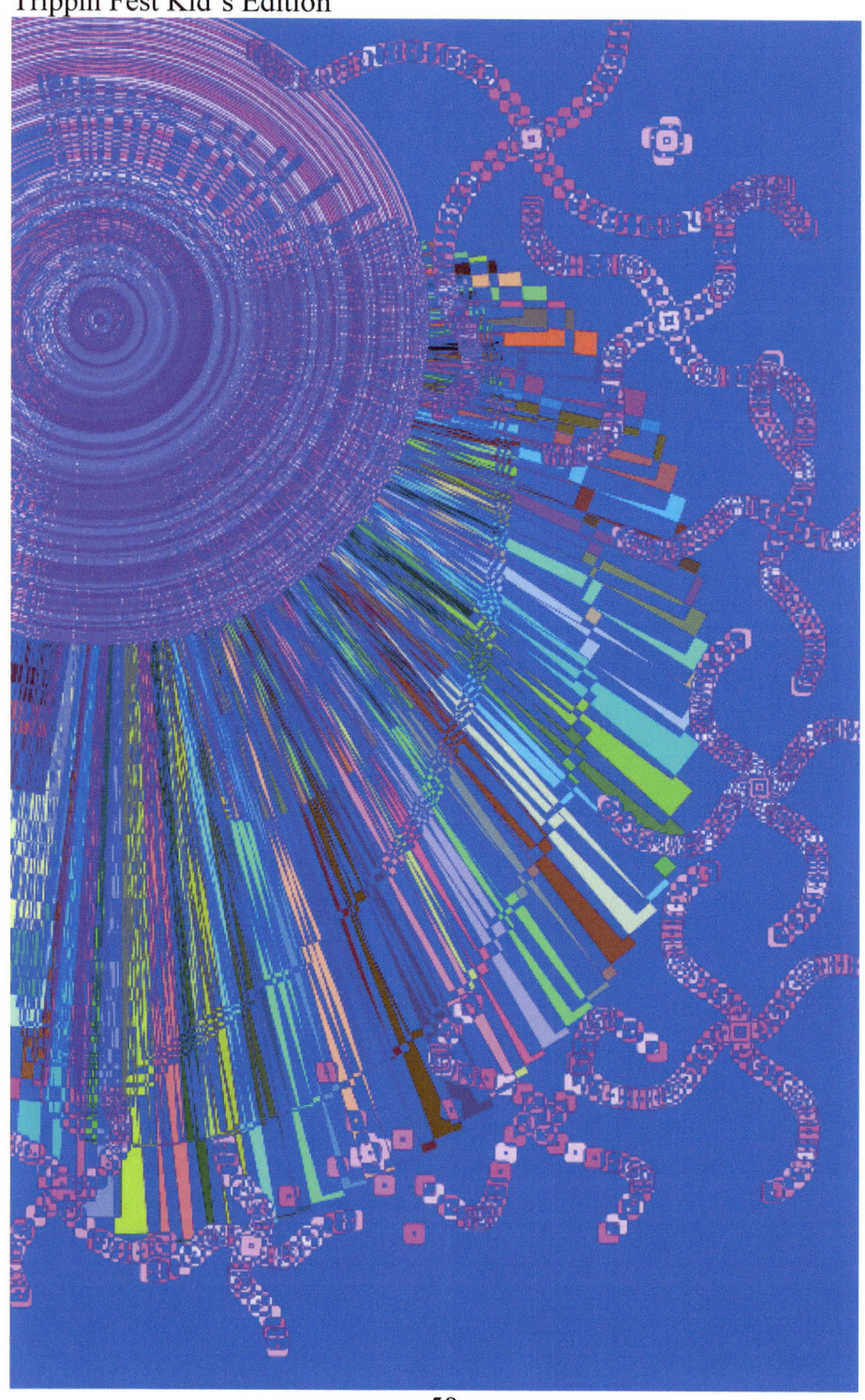

Trippin Fest Kid's Edition

Trippin Fest Kid's Edition

Trippin Fest Kid's Edition

Trippin Fest Kid's Edition

Trippin Fest Kid's Edition

Trippin Fest Kid's Edition

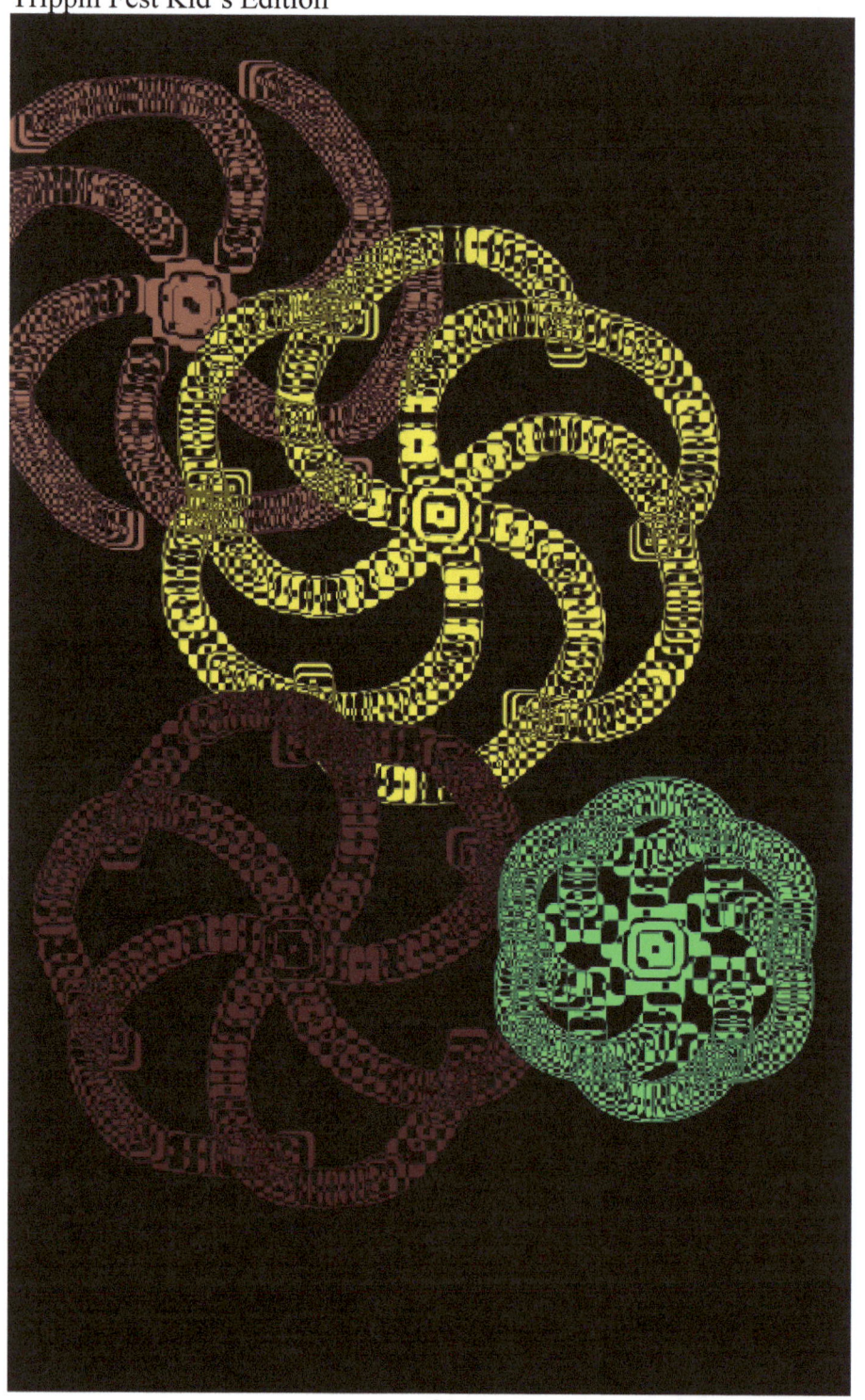

Trippin Fest Kid's Edition

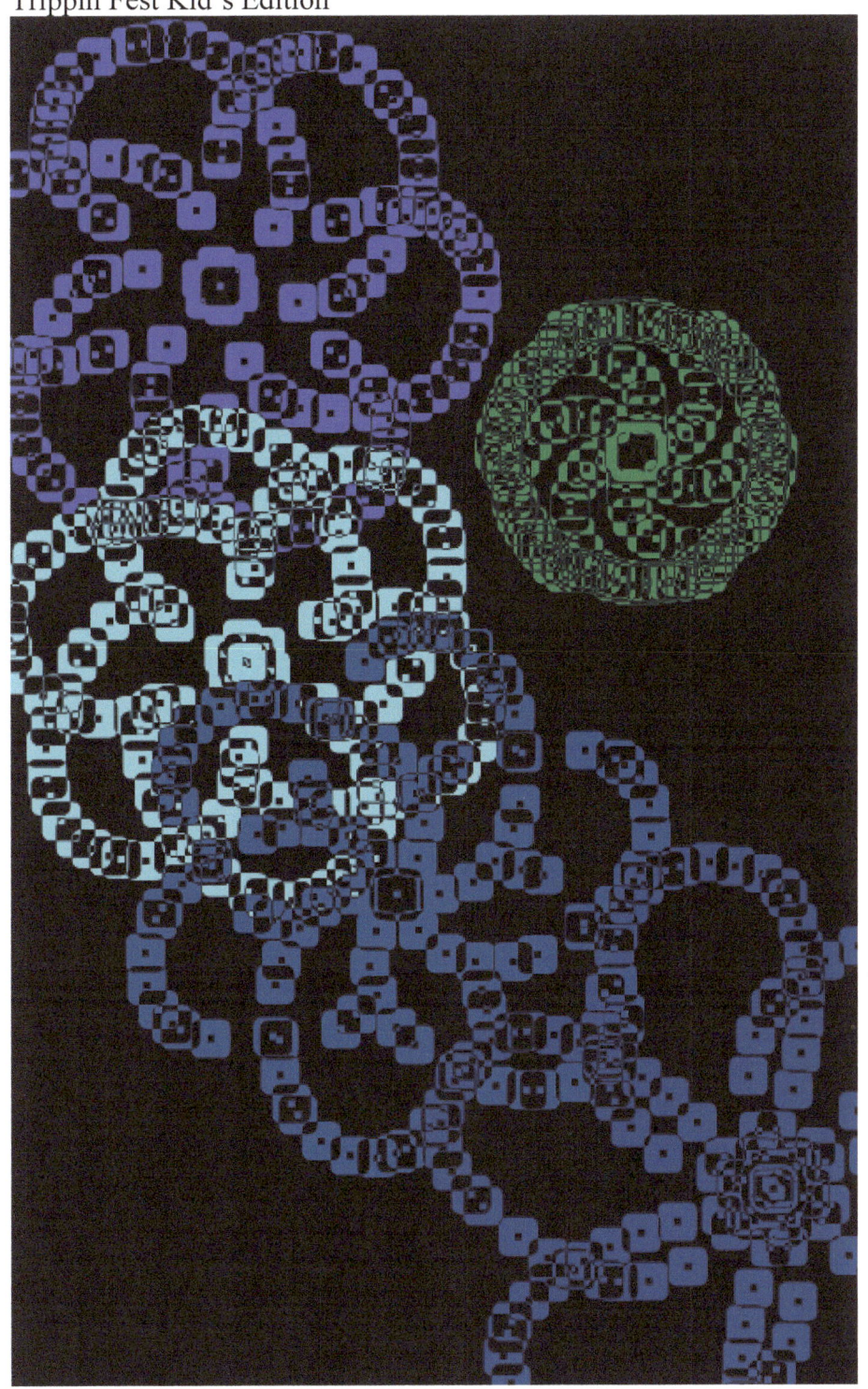

Trippin Fest Kid's Edition

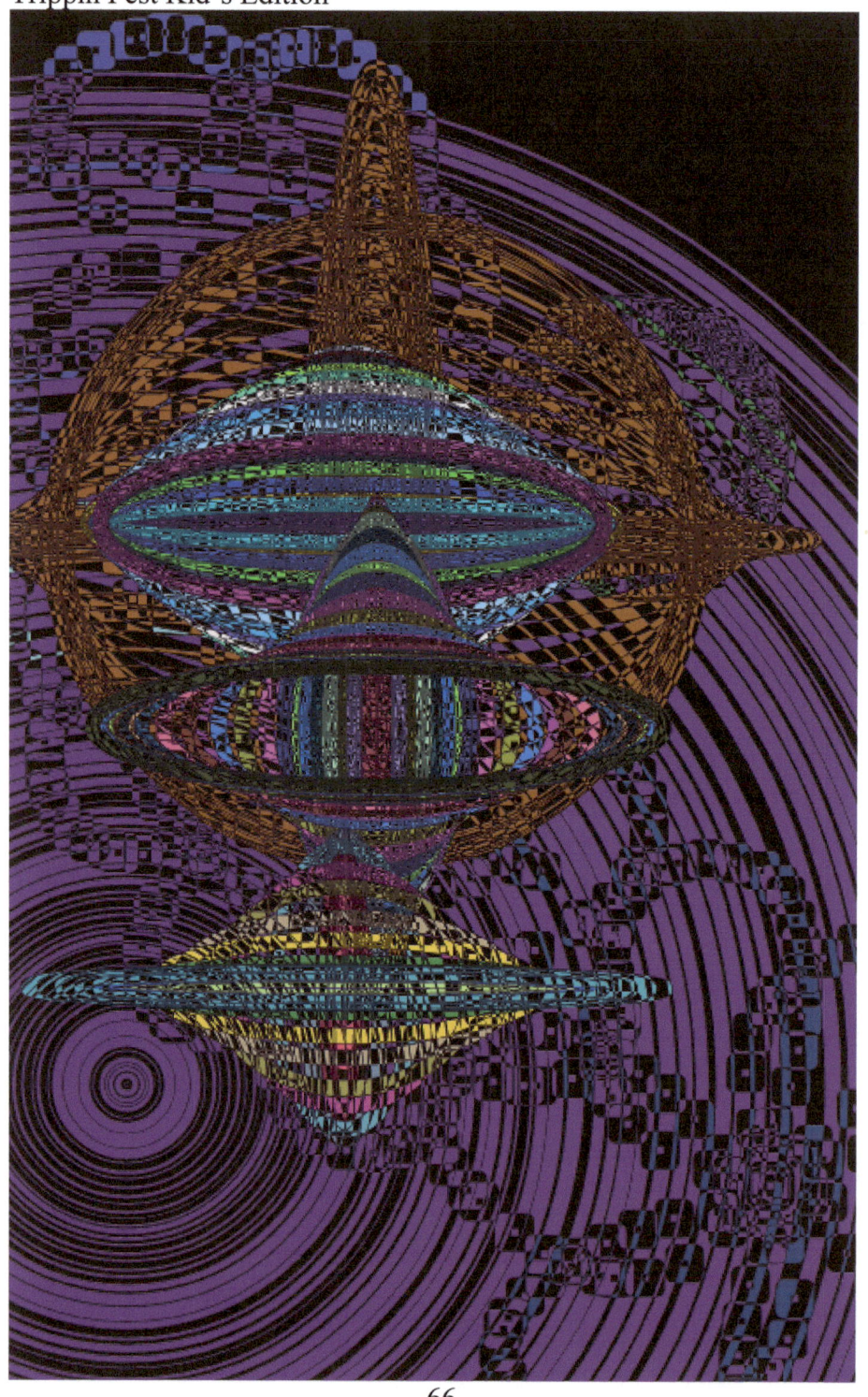

Trippin Fest Kid's Edition

Trippin Fest Kid's Edition

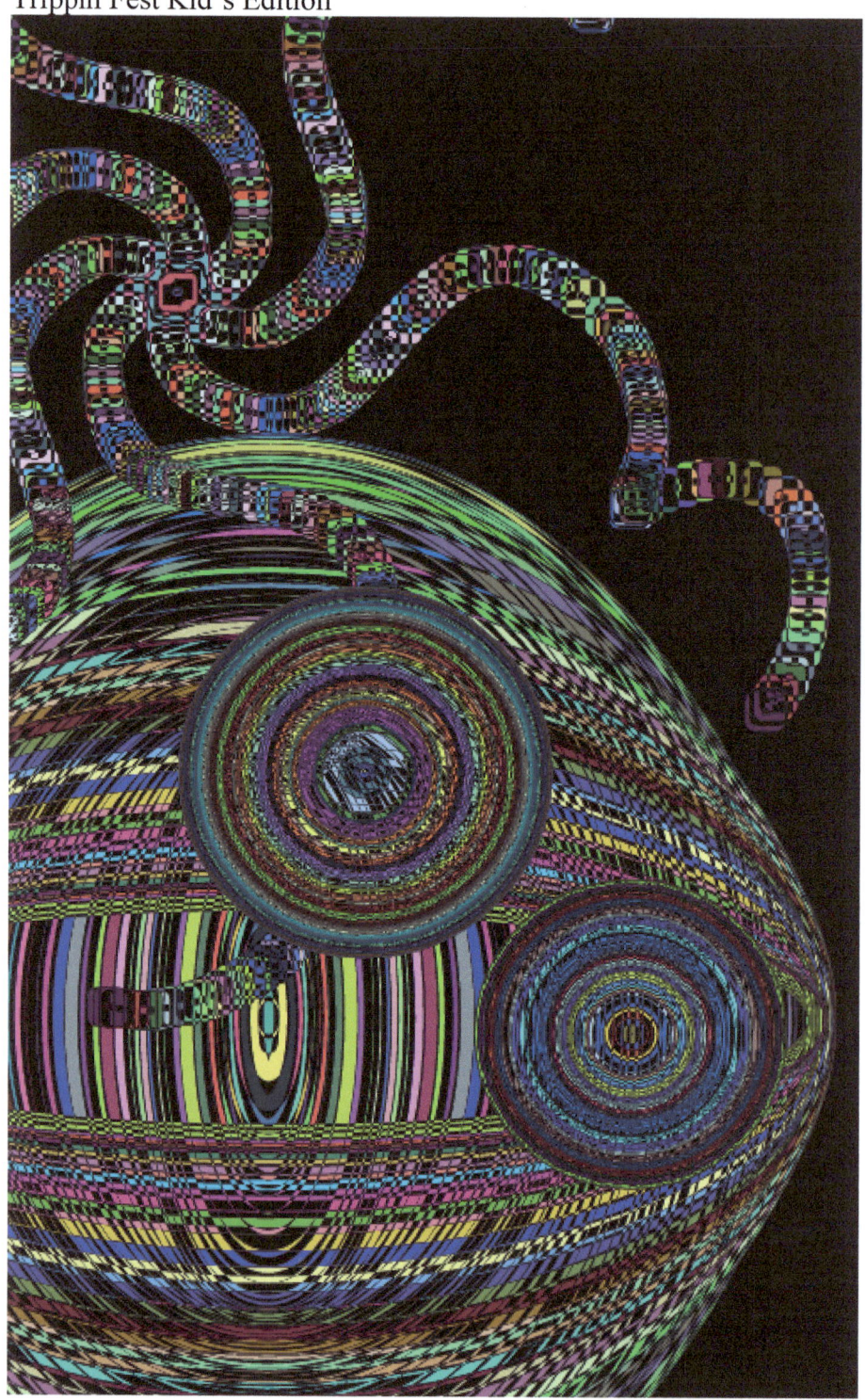

Trippin Fest Kid's Edition

Trippin Fest Kid's Edition

Trippin Fest Kid's Edition

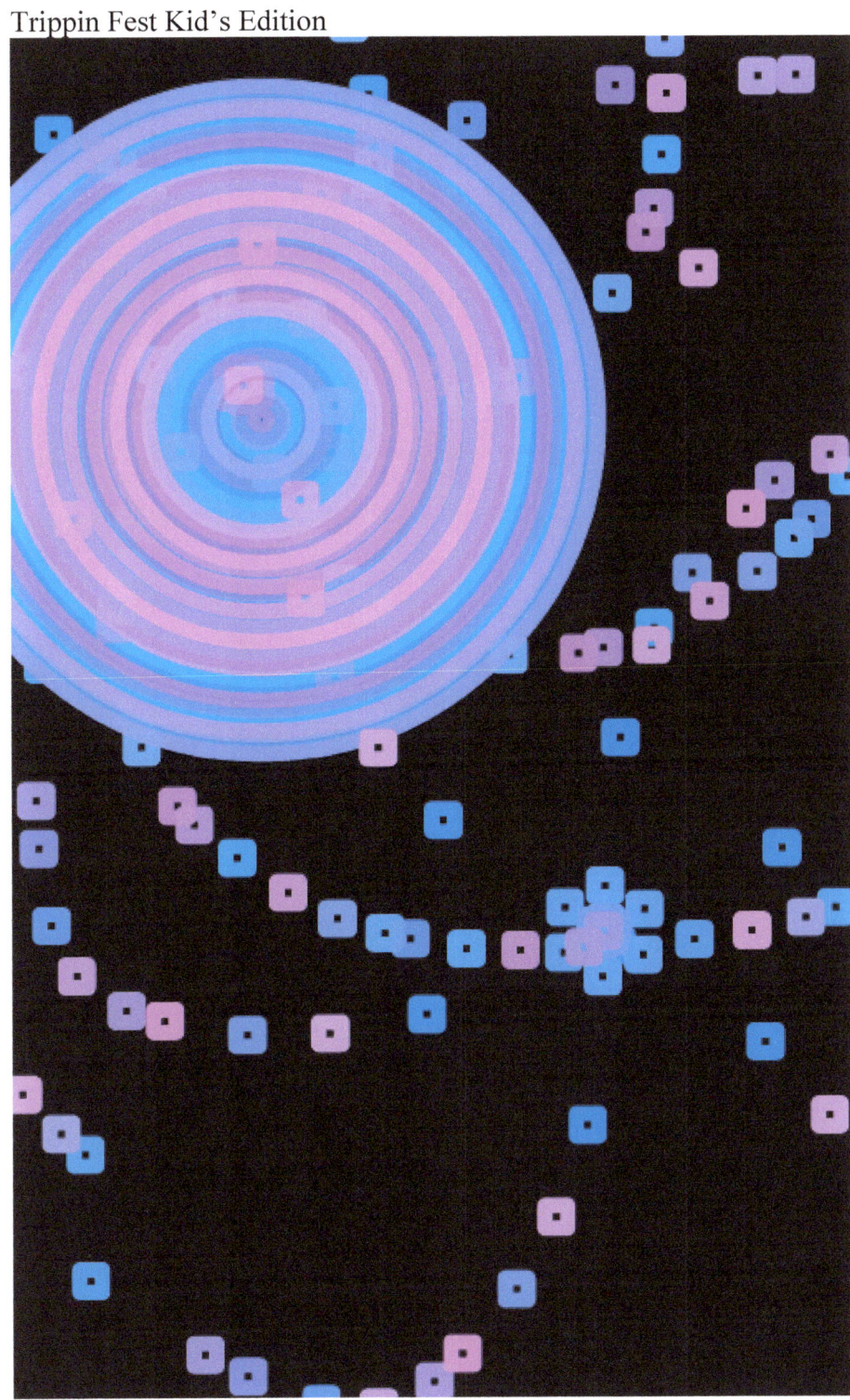

Trippin Fest Kid's Edition

Thank you for viewing the artwork in our first edition Trippin Fest gallery!

If you enjoyed these creations, please visit my website for a vast array of artwork created by Jewels Gold.

www.wix.com/janekey/jag

Also, there is a fun and unique way to enjoy all of your favorite art pieces by simply ordering form an array of great custom gifts at:

www.zazzle.com/jewelsgoldwebdesigns

Visit www.amazon.com for additional copies of this book and many other great books created by Jewels Gold.

www.ingramcontent.com/pod-product-compliance
Lightning Source LLC
Chambersburg PA
CBHW040810200526
45159CB00022B/203